MONTE NAGLER'S MICHIGAN

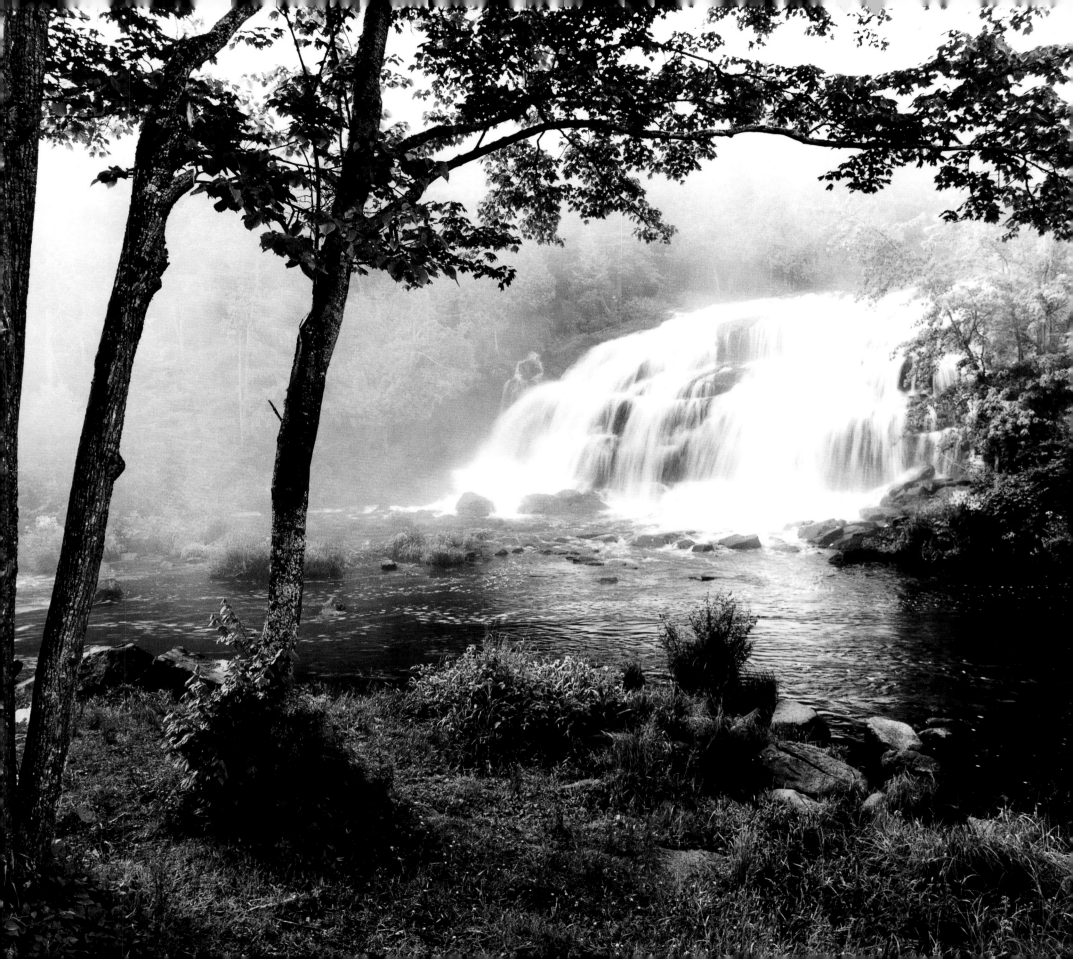

Monte Nagler's

MICHIGAN

Monte Nagler (signature)

THE PHOTOGRAPHS OF *Monte Nagler*

WITH A FOREWORD BY *Governor Jennifer M. Granholm*

THE UNIVERSITY OF MICHIGAN PRESS ANN ARBOR

Published in the United States of America by
The University of Michigan Press
Printed and bound in China
∞ Printed on acid-free paper

2008 2007 2006 2005 4 3 2 1

A CIP catalog record for this book is available from the British Library.

Library of Congress Cataloging-in-Publication Data

Nagler, Monte.
 Monte Nagler's Michigan : photographs / by Monte Nagler ; with a
foreword by Jennifer M. Granholm.
 p. cm.
 ISBN 0-472-11420-4 (cloth : alk. paper)
 1. Michigan—Pictorial works. 2. Michigan—History, Local—Pictorial
works. 3. Natural history—Michigan—Pictorial works. I. Title.

F567.N34 2005
917.74'0022'2—dc22 2004029711

Monte Nagler and the University of Michigan Press gratefully acknowledge
the generous contribution of the BASF Corporation in support of the
publication of this volume.

Monte Nagler and the University of Michigan Press gratefully acknowledge
the generous contribution of Visteon Corporation in support of the
publication of this volume.

*This book is dedicated to all
who share a passion for experiencing
the splendid landscapes and
numerous wonders of Michigan*

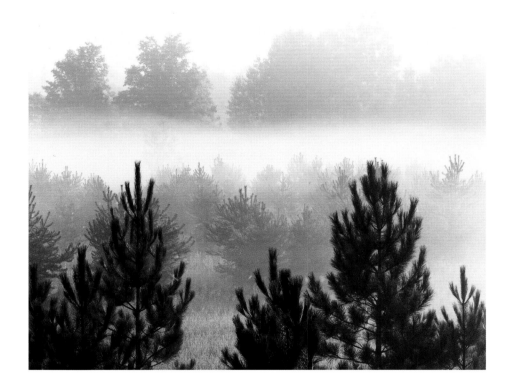

Foreword

Michigan's well-known motto is "if you seek a pleasant peninsula, look about you." Few things embody that invitation better than the book you hold in your hands—*Monte Nagler's Michigan*. The black and white photographs here present an irresistible inducement to explore the wonders, the seasons, and the diverse landscapes that are Michigan.

From the skyscrapers and great public art of Detroit, to the spring tulips of Holland and the silvery rush of countless waterfalls, to the serenity of a foggy autumn sunrise and the pristine stillness of a winter woods cloaked in snow, Monte Nagler's luminous photographs capture the majesty of the State of Michigan . . . the nation's "third coast."

As one of our state and national treasures, photographer Monte Nagler hardly needs an introduction. This award-winning artist has works in numerous collections, including the Detroit Institute of Arts, the Grand Rapids Art Museum, and the Center for Creative Photography in Tucson. In the tradition of his mentor, the artist and teacher Ansel Adams, Monte also shares the knowledge of and passion for his craft through the many lectures, workshops, and field trips he conducts around the world.

Like the best art, Monte's pictures are more than meets the eye. His breathtaking images work on two levels simultaneously. They evoke an idealized view, a place of the imagination, while at the same time they are very real portraits—as if they were perfect tableaux waiting for that first shiver of discovery—of timeless scenes that need no further embellishment. These are the many faces of Michigan that shift with the seasons in their elemental splendor.

Apart from their sheer beauty, Monte's photographs also foster a greater appreciation of the amazing diversity of the Michigan landscape, as well as make us more aware that we are all stewards of our natural resources, and that each of us plays a part in valuing and preserving the land.

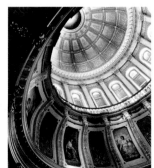

I can't imagine a better display of our magnificent state, or a way to share with the world the work of a brilliant Michigan artist, than *Monte Nagler's Michigan*.

Governor Jennifer M. Granholm

Preface and Acknowledgments

To look at a satellite image of the United States, Michigan is immediately recognizable. Surrounded by four of the five Great Lakes, you see the distinctive mitten shape of the Lower Peninsula pointing north toward the Upper Peninsula. Indeed, ask someone from Michigan where they live and you're likely to see them turn their palms up and point to the proper location, using the right hand for the Lower Peninsula, and the left for the Upper.

I am proud to say that I have always lived in Michigan. From my childhood I recall the varied smells of spring, the wide array of greens in summer, the crispness of autumn, and the sparkling snow of winter. To this day I enjoy experiencing the full beauty of our four seasons. I have traveled and photographed throughout much of the United States and in many parts of the world, yet I always return home to Michigan.

Michigan offers a variety of scenic splendor that very few states can match. First, there are the miles and miles of coastline, from the rocky Lake Superior shores to the sandy dunes along Lake Michigan. In between are expansive forests, productive fields and orchards, and lively rivers, lakes, and waterfalls. Michigan is a state that balances industry and art, a region that shares the places we work with those where we play.

The scenes and seasons of Michigan automatically evoke colorful and vibrant images. With this book, however, I offer you my interpretation of the Michigan landscape through black and white photography. The textures, tones, and contrasts put an emotion and drama into the scene that is far different from what color photos provide. From the early morning fog at Eagle Harbor to the magnificent dome of the state capitol, black and white photography enables me to express my feelings about the subjects placed before my viewfinder.

To capture a fleeting moment on film is a true joy. I want to share with you the joy and intimacy of what I saw and felt as I traveled across Michigan. It is my hope that these images will stir your emotions and provoke you to see this great state through a finer light and to appreciate even more all that Michigan has to offer.

I can think of no one more appropriate to write the foreword for this book than Governor Jennifer M. Granholm. Governor, many thanks for your graciousness in honoring my book with your kind and genuine words.

I would like to acknowledge my new friends at the University of Michigan Press, especially my editor, Kevin Rennells, with whom I worked closely and pleasurably from the birth of the idea of the book through its completion. I also thank the BASF Corporation and Visteon Corporation for their financial support of this endeavor. Also special thanks to Richard Rabinowitz, Christopher Robinson, Dennis Archer, Tom Halsted, and Robert Stewart for their meaningful testimonials.

But most of all, I thank my wife, Mickey. She was right there at my side from the beginning, and her heartfelt support, encouragement, and endless supply of ideas helped make this book possible.

Monte Nagler
December 2004

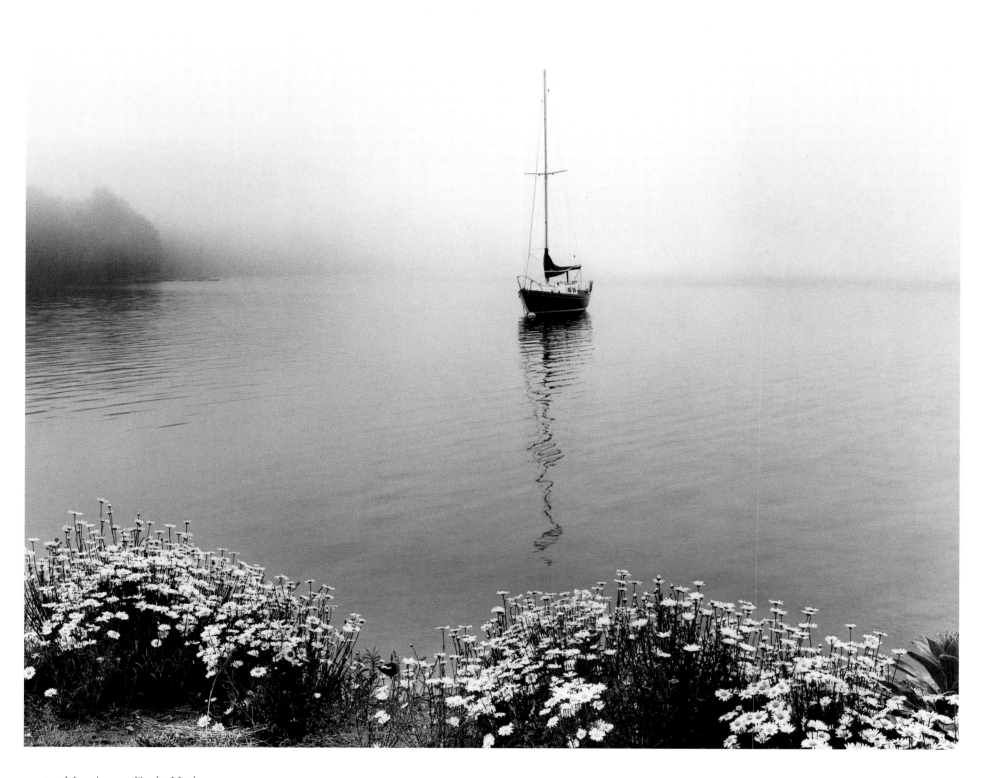

1 *Morning at Eagle Harbor*
EAGLE HARBOR

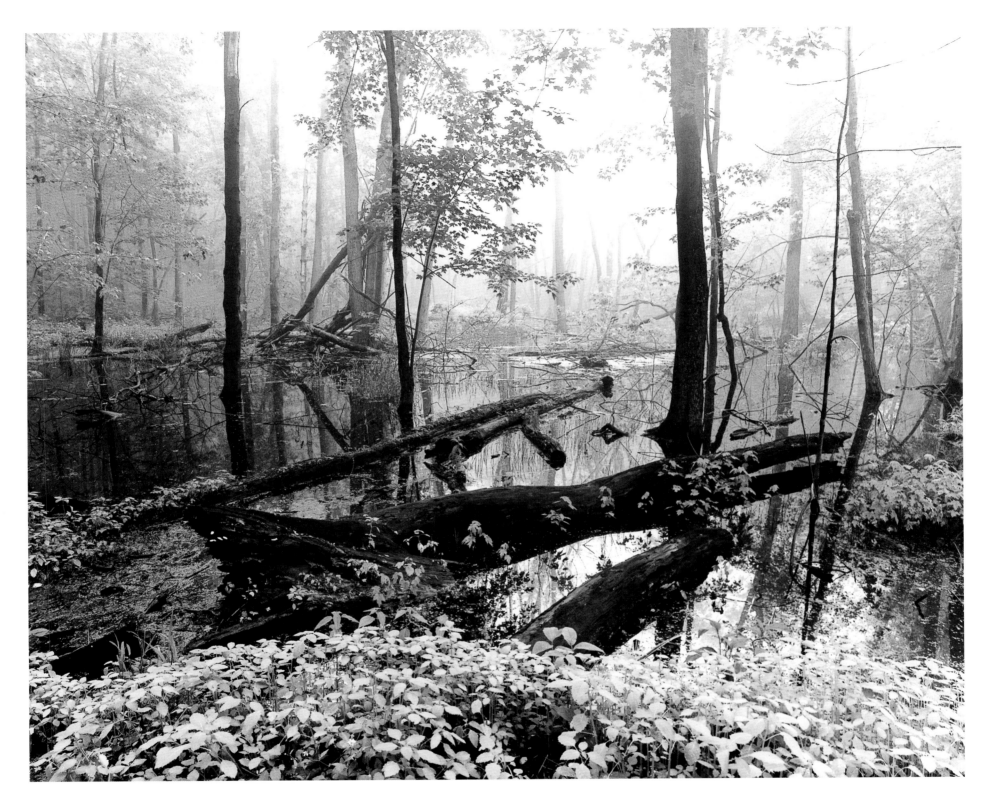

2 ❧ *Wetlands*
WALLED LAKE

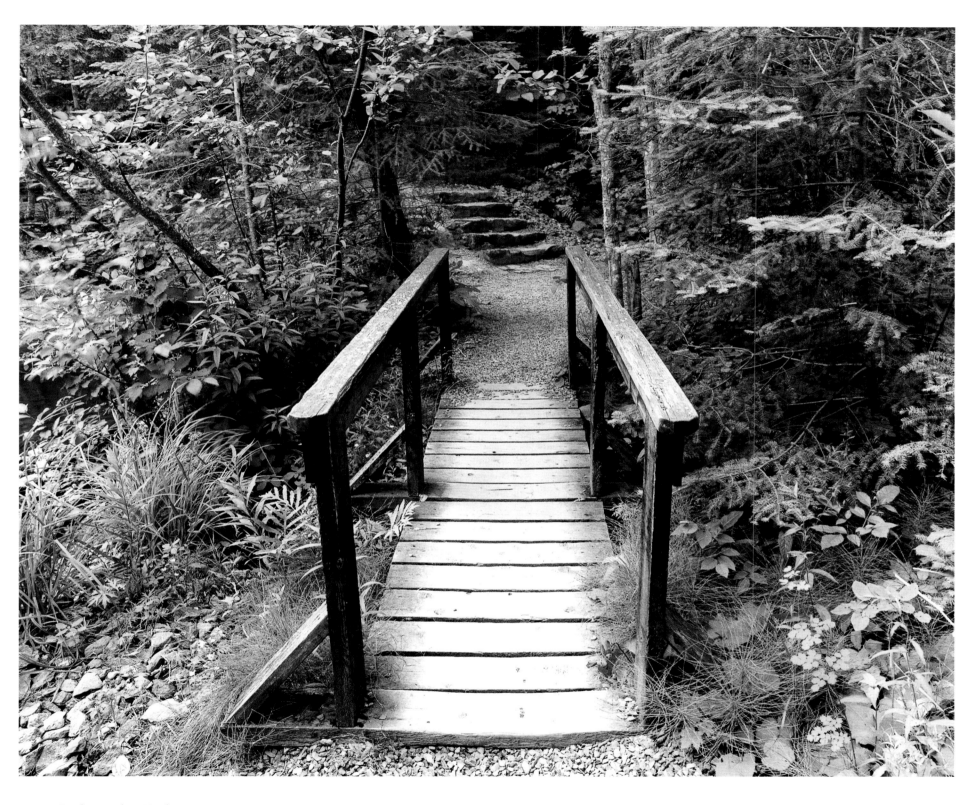

3 ❧ *Bridge in the Woods*
PAULDING

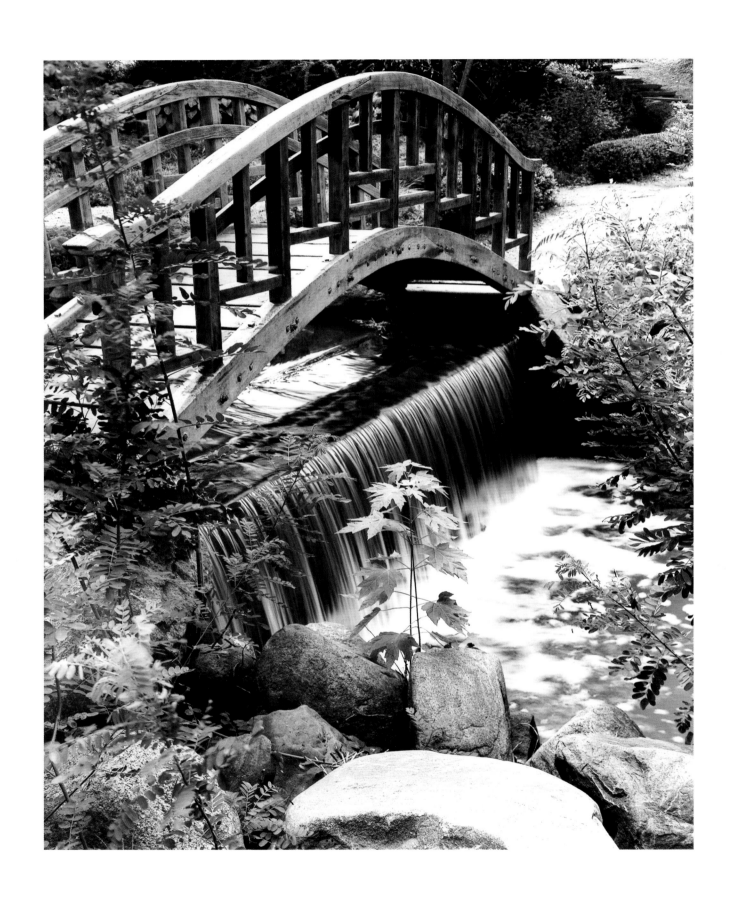

4 ❧ *Oriental Bridge*
CRANBROOK GARDENS,
BLOOMFIELD HILLS

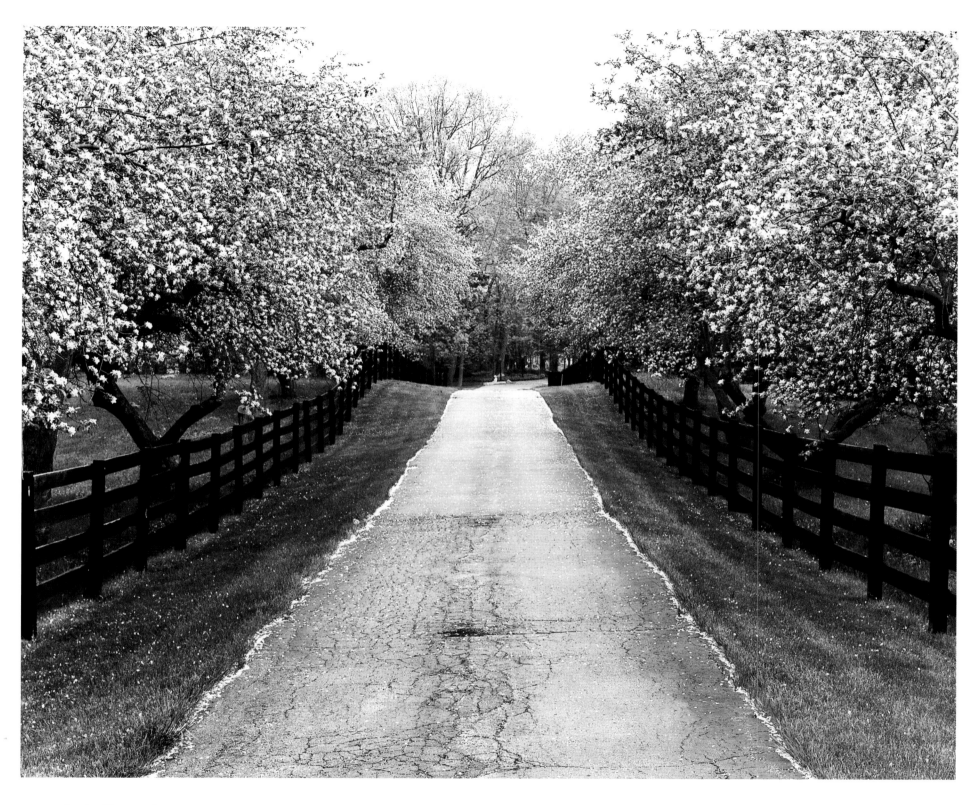

5 ❧ *Apple Blossom Lane*
WEST BLOOMFIELD

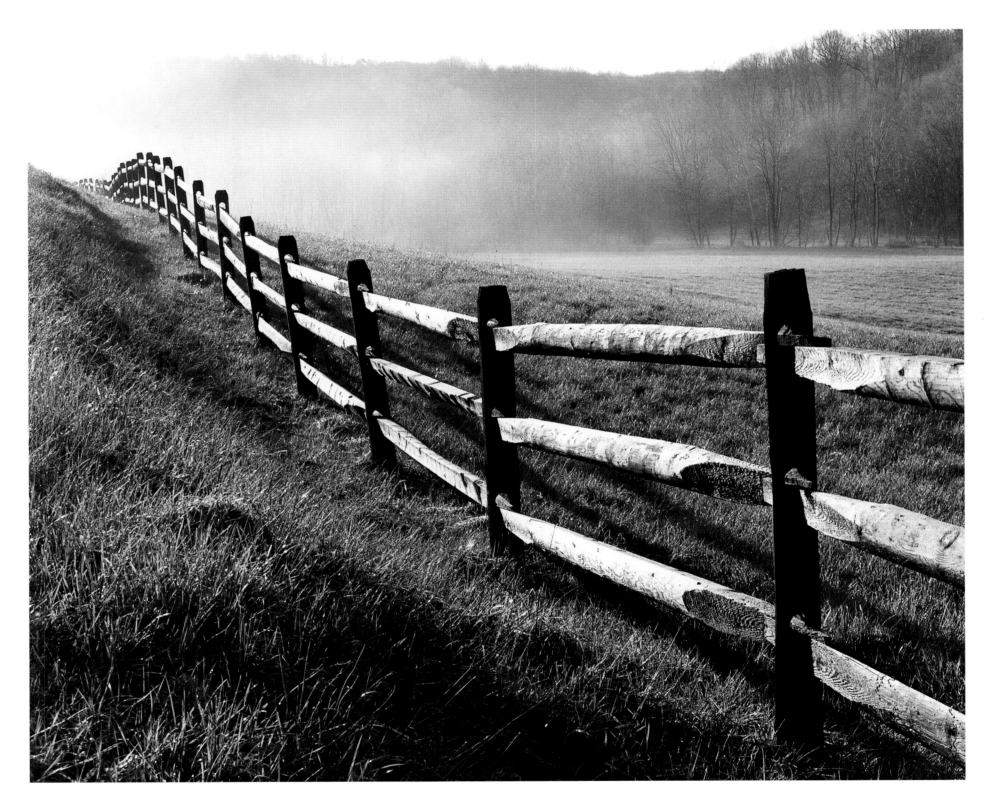

6 *Vanishing Fence*
BAD AXE

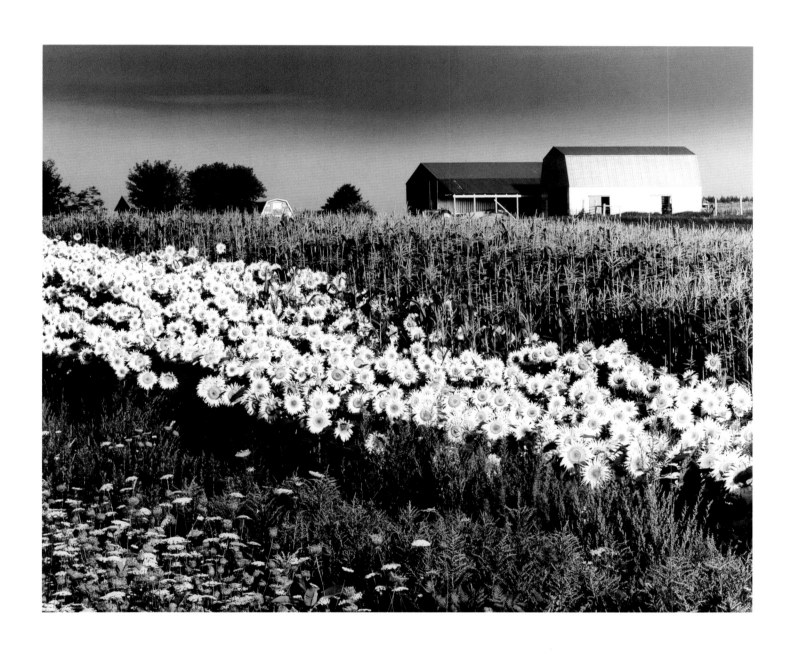

7 ❧ *Sunflower Field*
WILLIAMSBURG

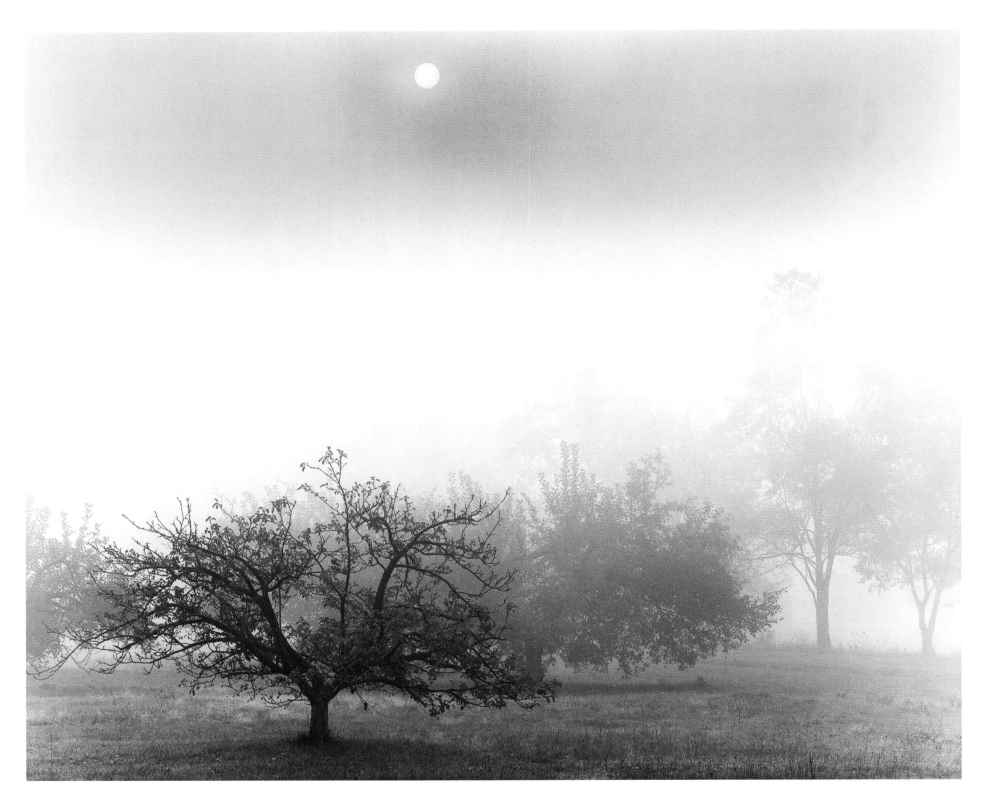

8 ❧ *Early Morning Mist*
SOUTHFIELD

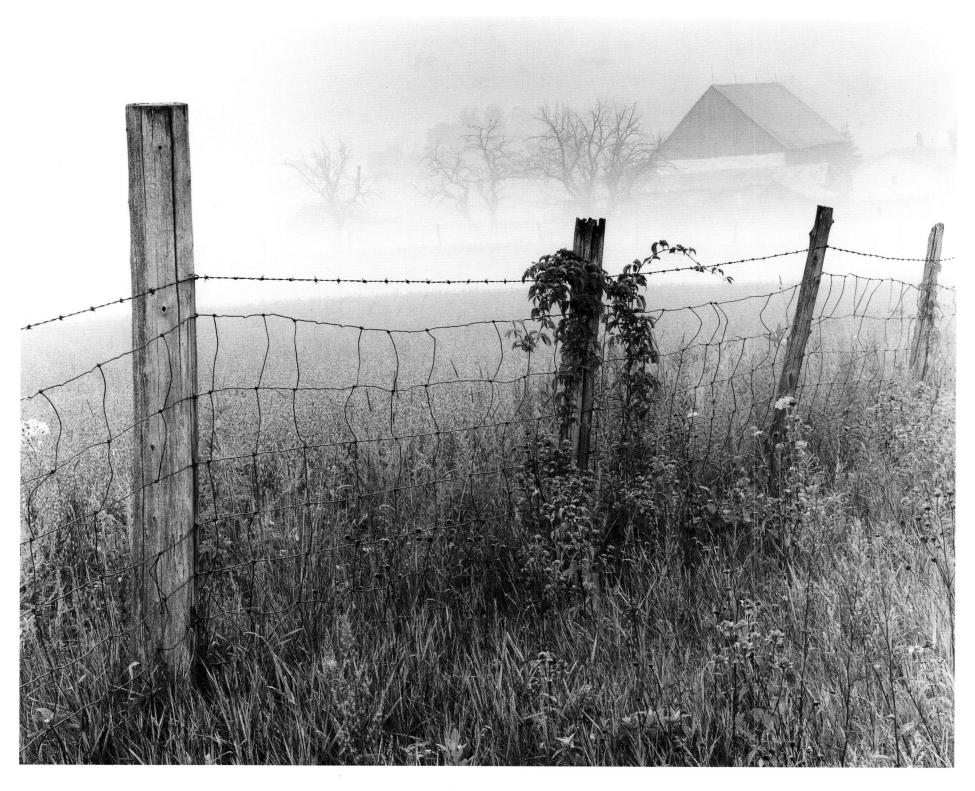

9 🎋 *Farm in the Mist*
WEST BRANCH

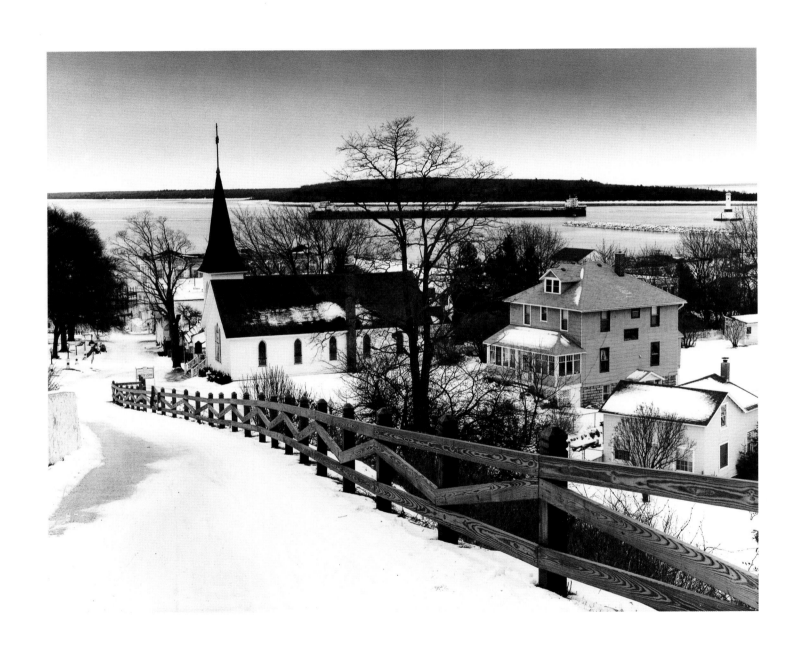

Winter on Fort Street,
10 ❧ *Trinity Episcopal Church*
MACKINAC ISLAND

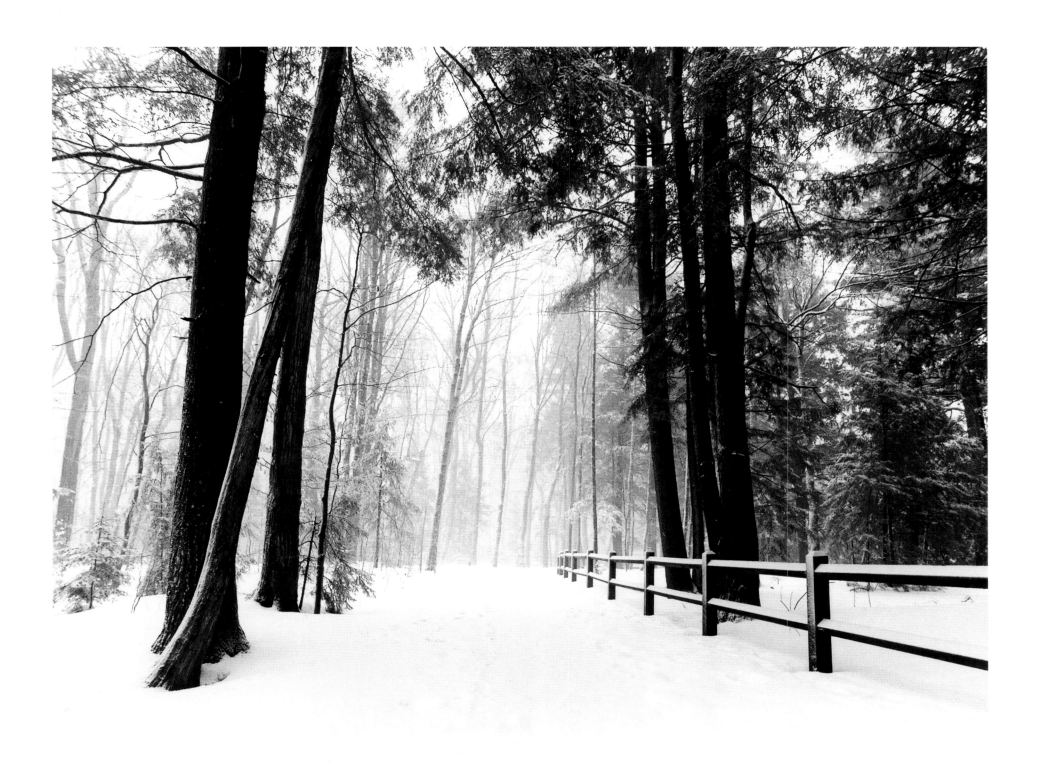

11 ❧ *Winter Path*
NEWBERRY

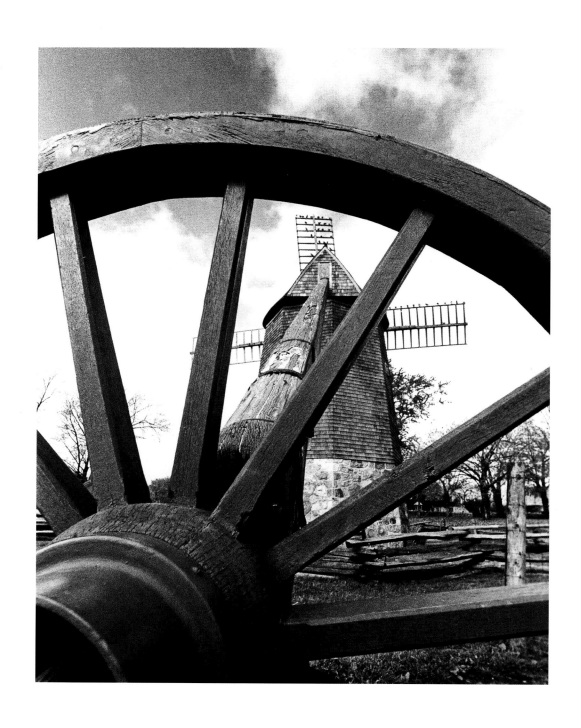

12 ❧ *Windmill at Greenfield Village*
DEARBORN

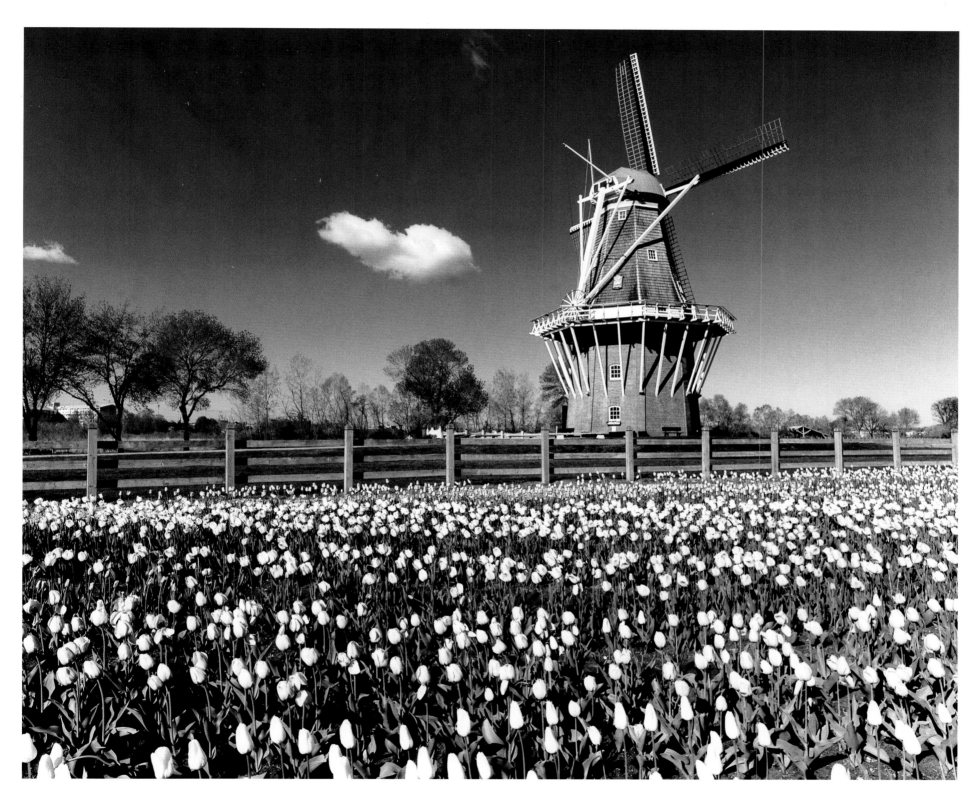

13 ❦ *Windmill & Tulips*
HOLLAND

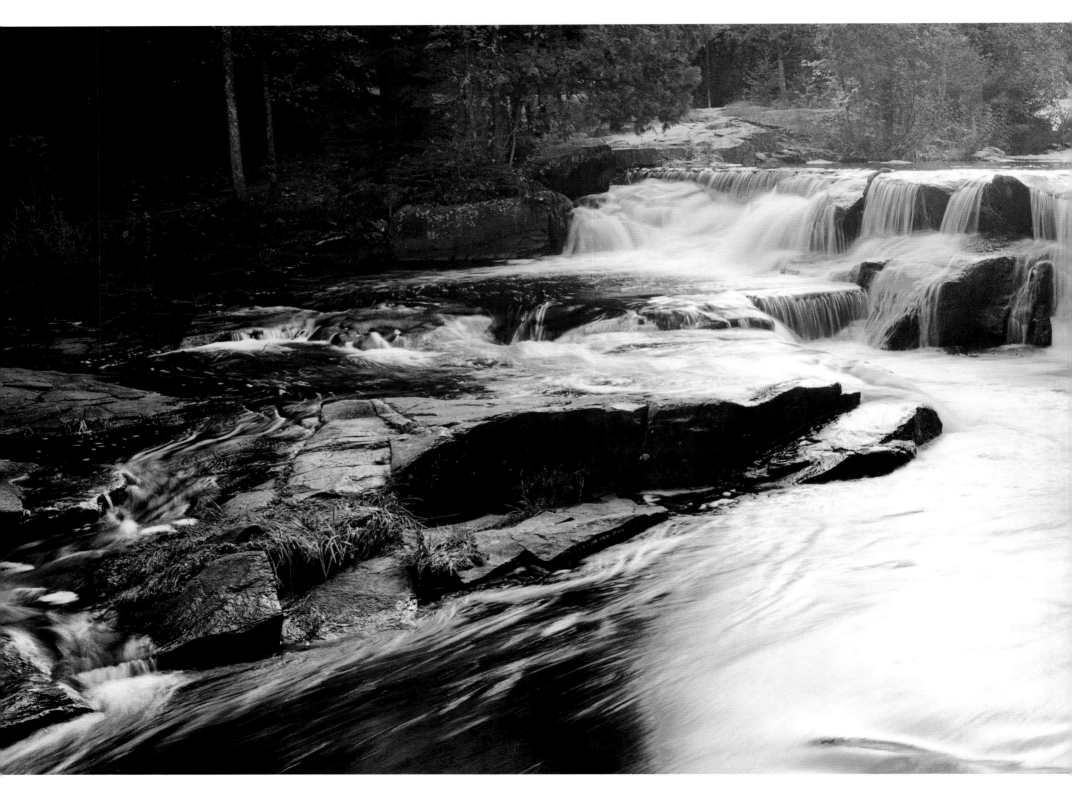

14 ✿ *Upper Bond Falls*
BRUCE CROSSING

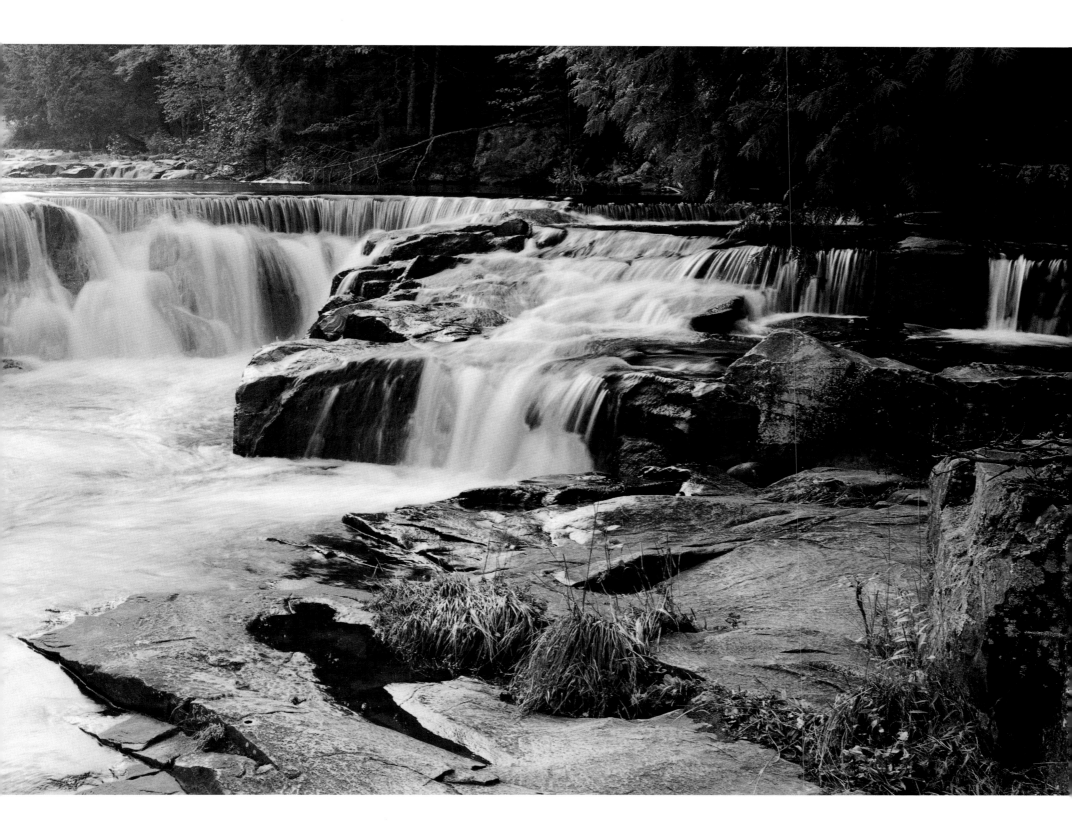

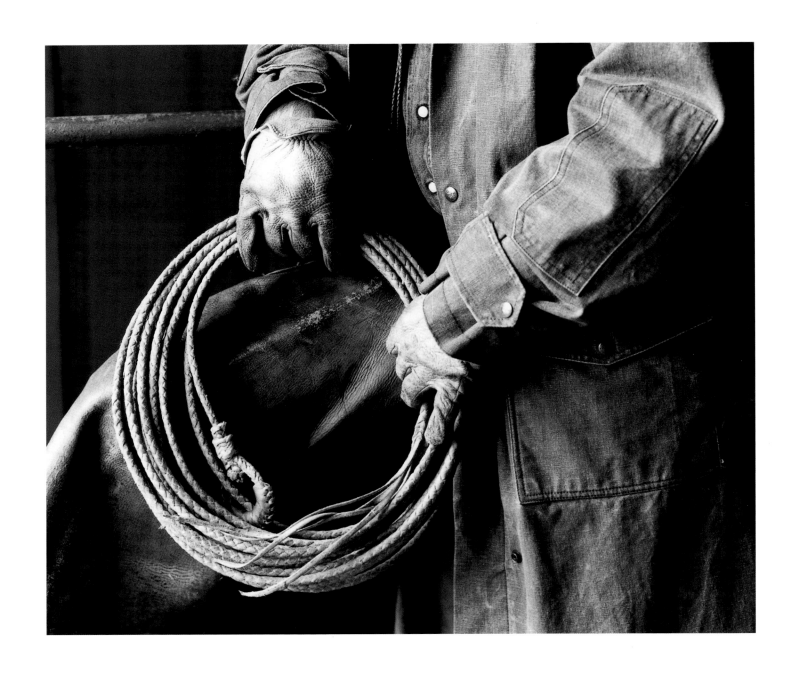

15 ❧ *Rope & Denim*
MONTAGUE

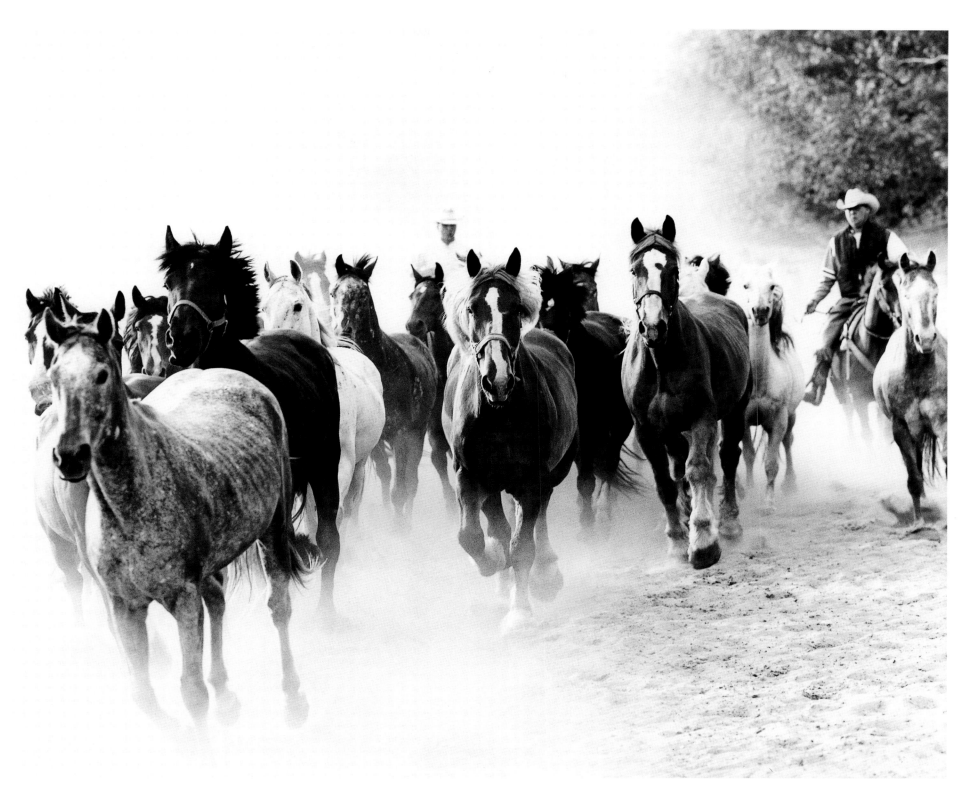

16 ❧ *Running Horses*
ROTHBURY

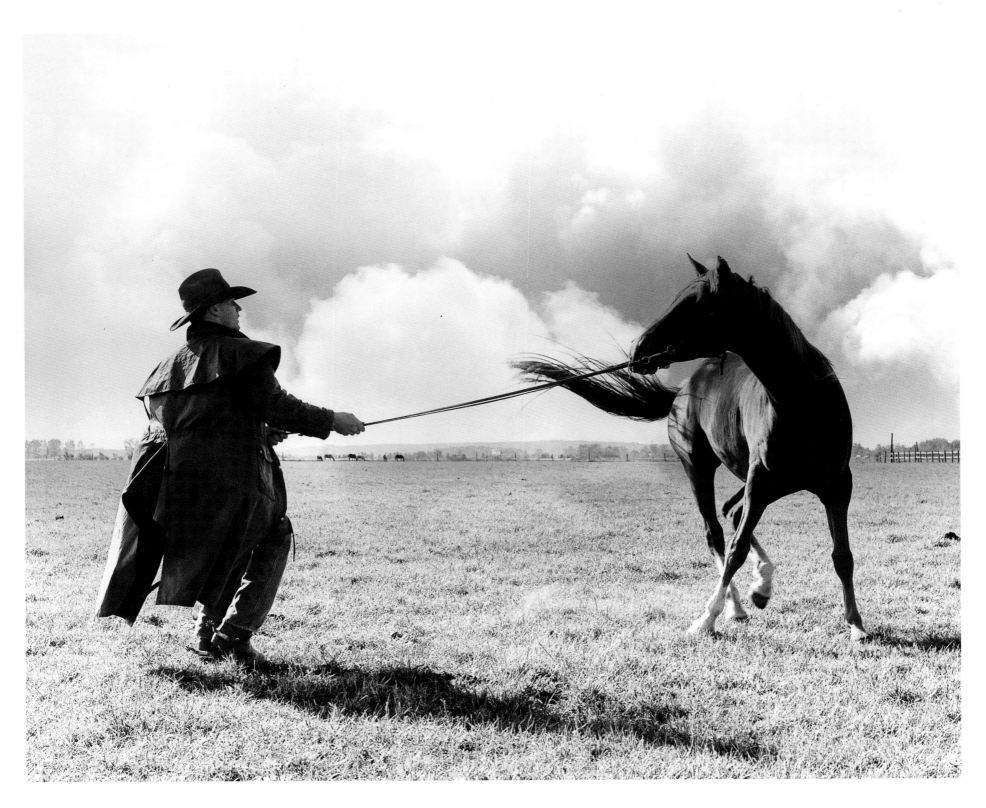

17 ❧ *Breaking Rein*

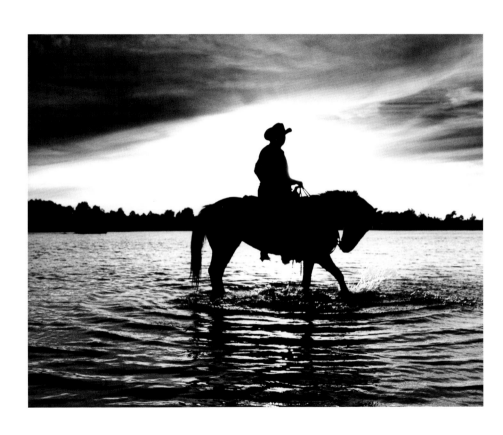

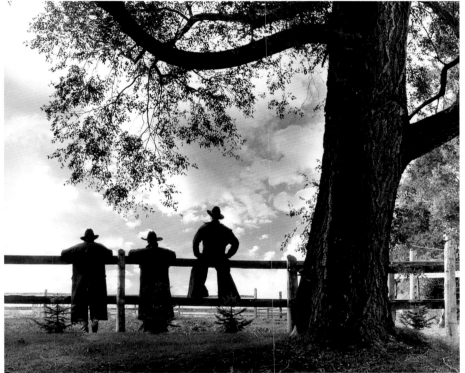

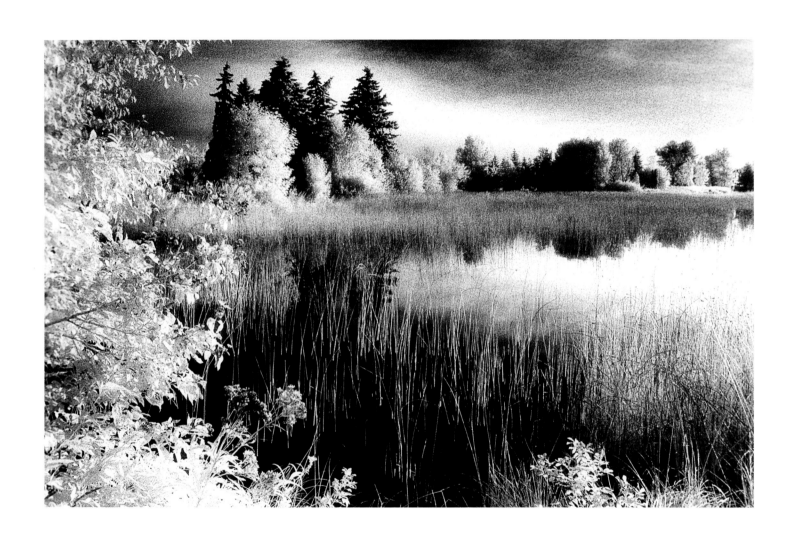

20 ❧ *Crooked Lake*
CONWAY

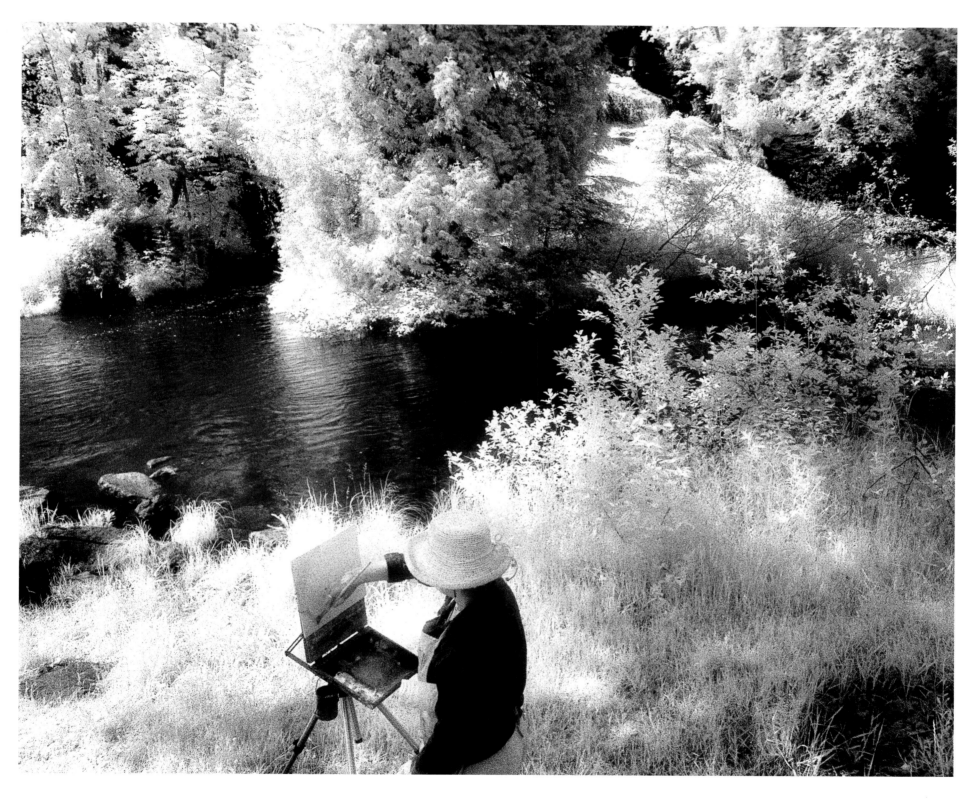

21 ❧ *The Artist*
PAULDING

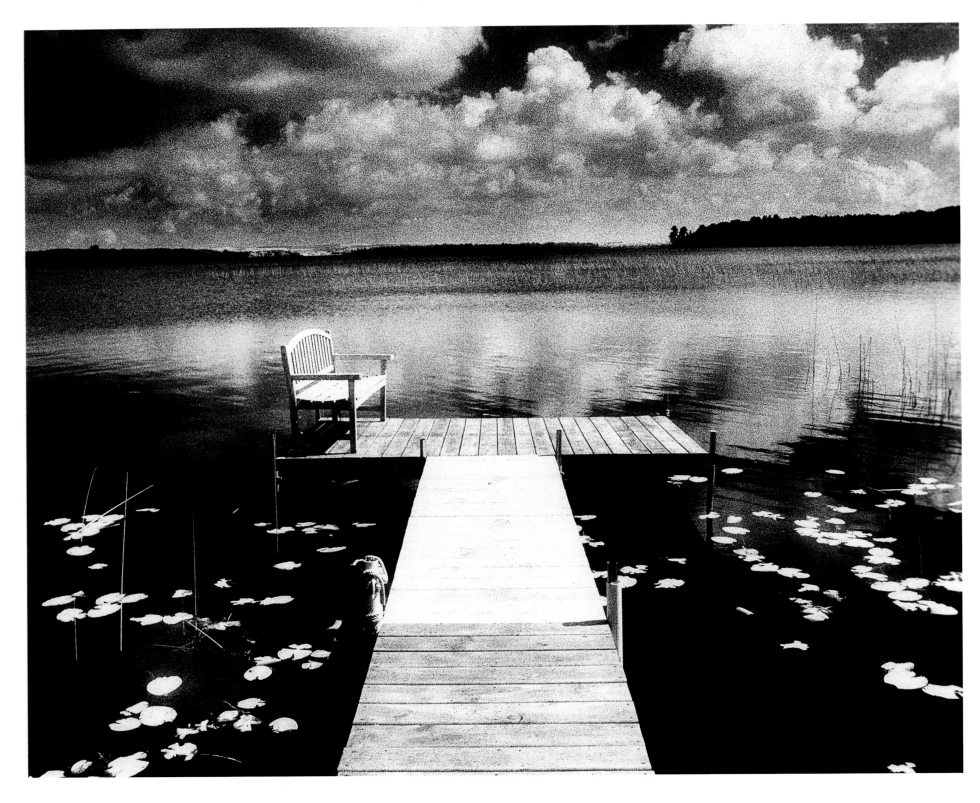

22 *Bench on the Dock*
CONWAY

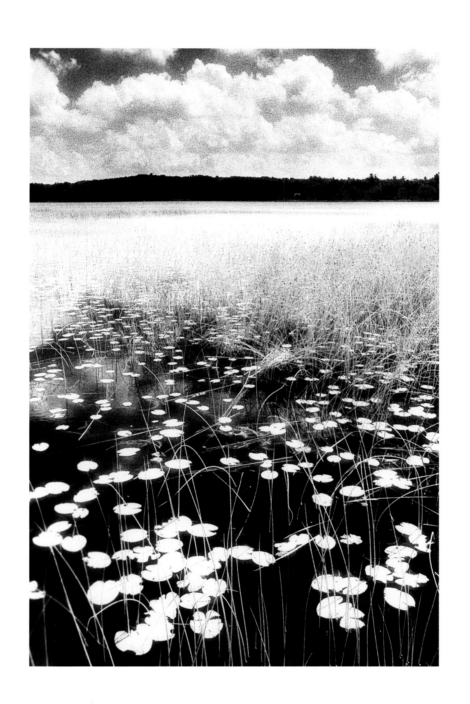

23 ❧ *Lily Pads at Crooked Lake*
CONWAY

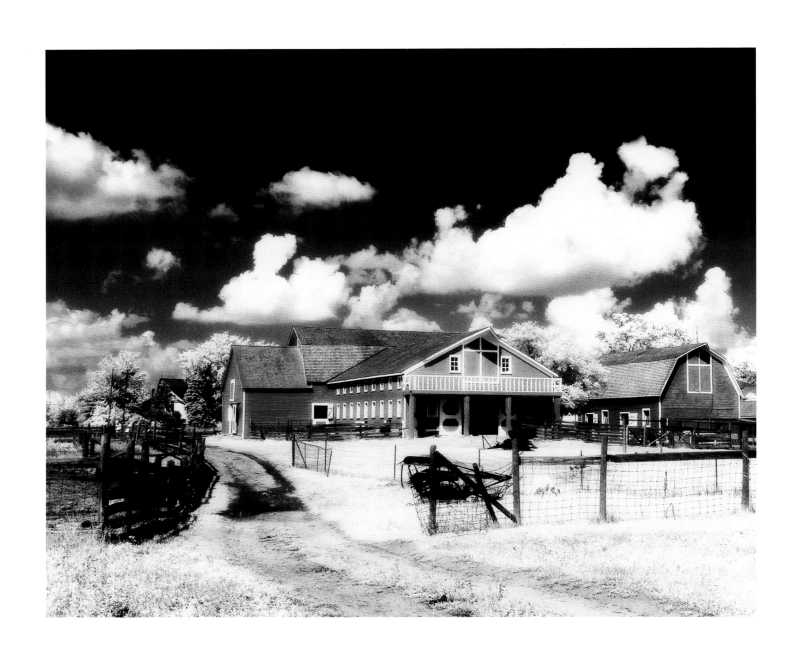

24 ❧ *The Farm at Maybury State Park*
NORTHVILLE

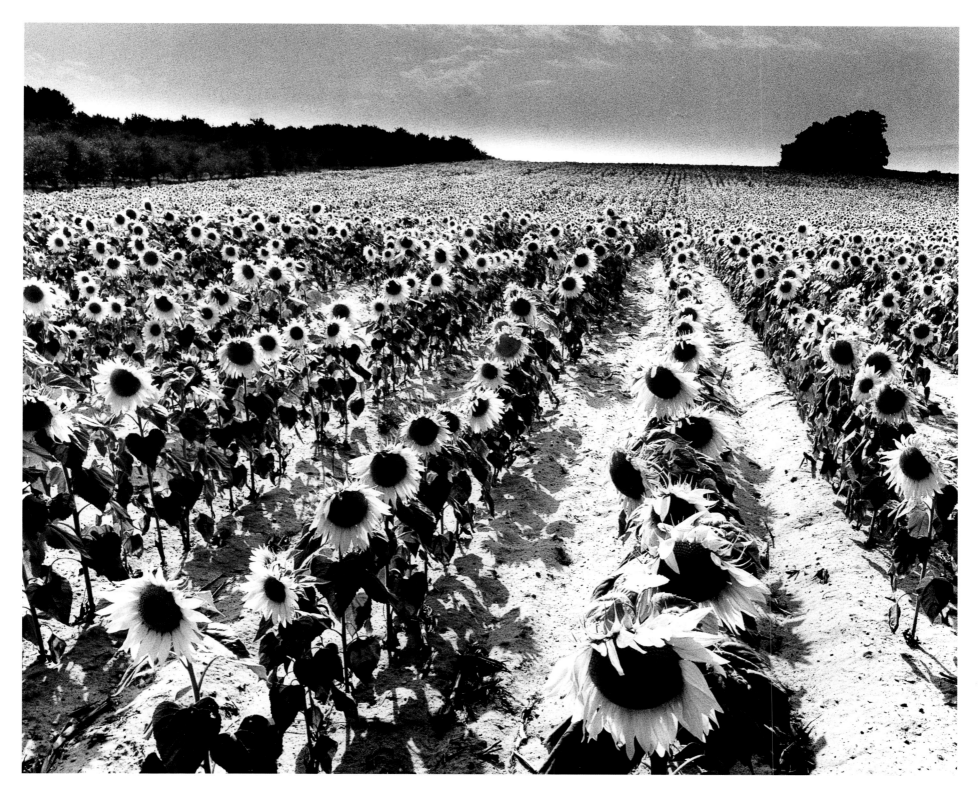

25 ❧ *Sunflower Sentinels*
ELK RAPIDS

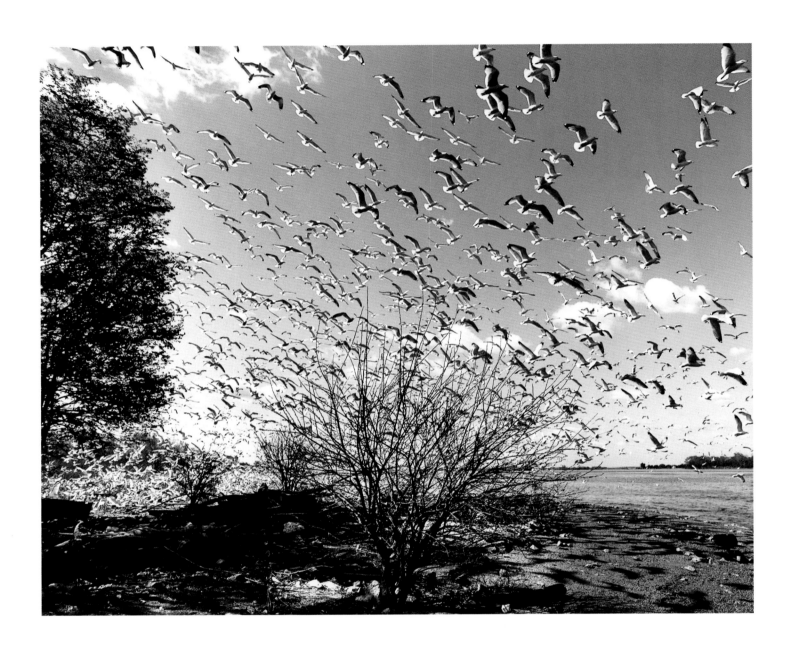

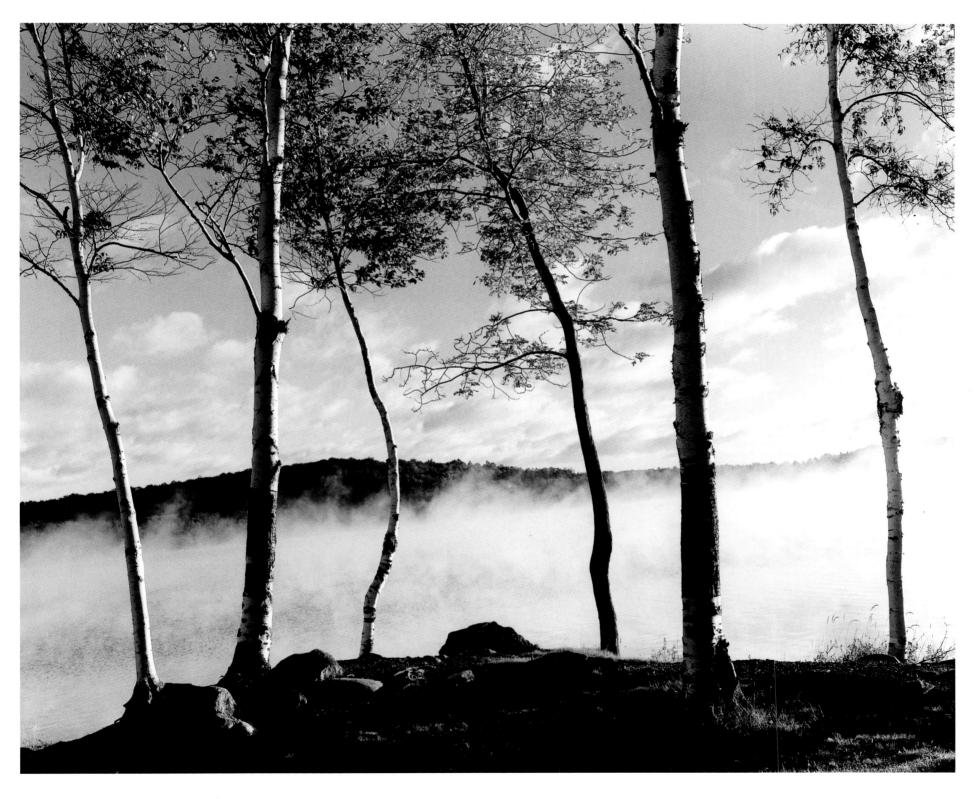

27 ❧ *Birch Trees & Mist*
NEGAUNEE

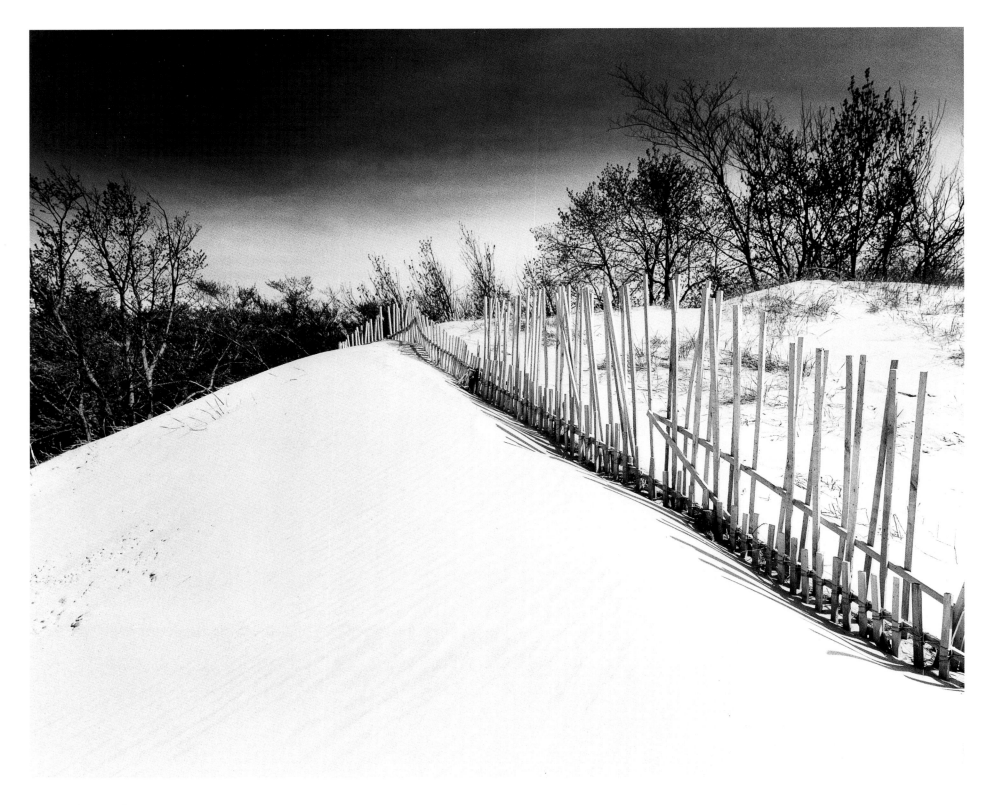

Dunes & Fence
SLEEPING BEAR DUNES NATIONAL LAKESHORE

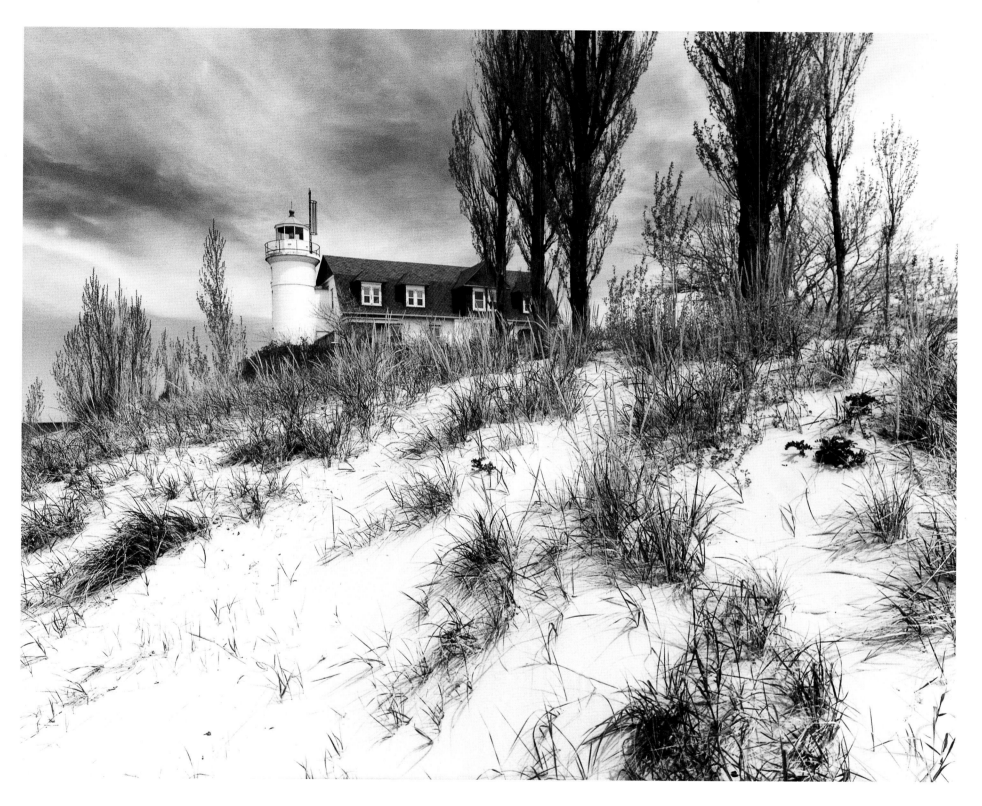

29 ❧ *Point Betsie Lighthouse*
FRANKFORT

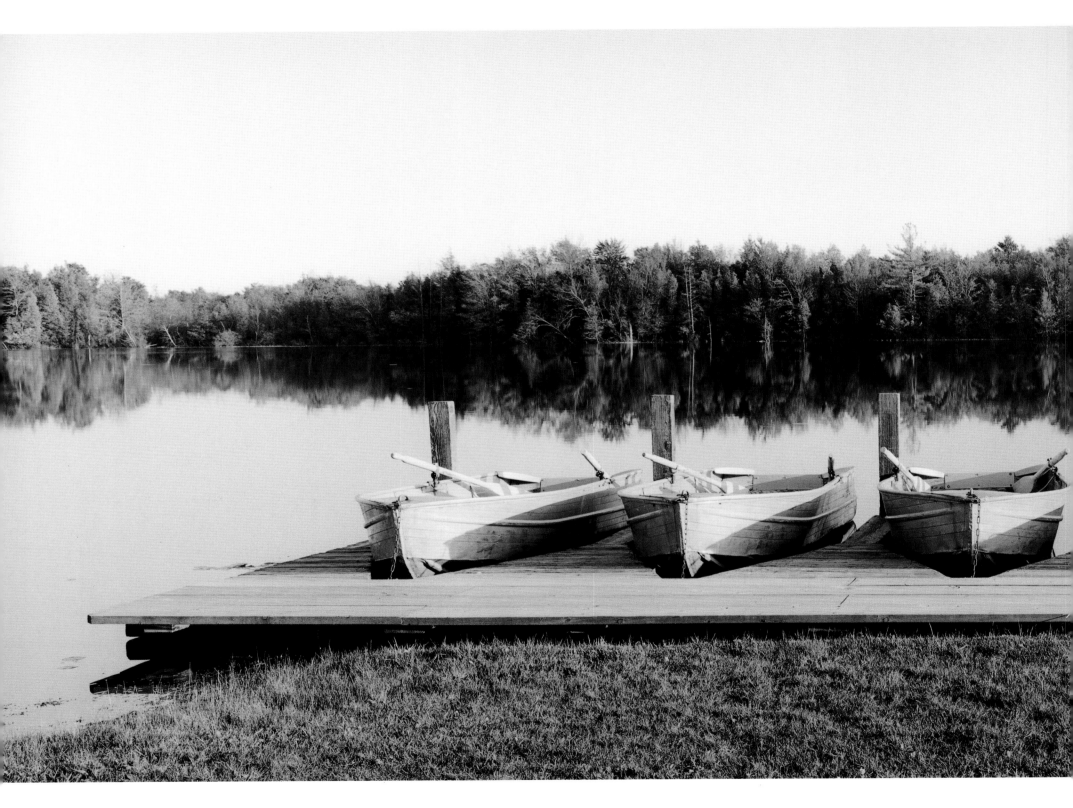

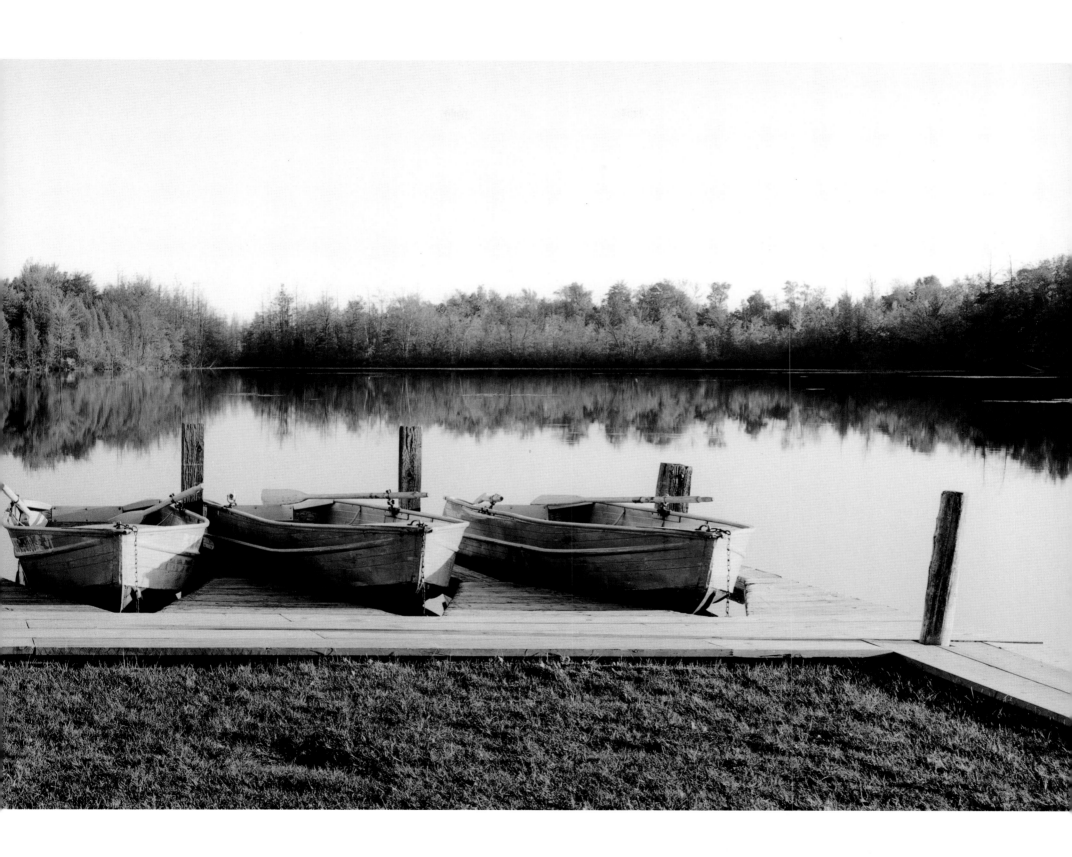

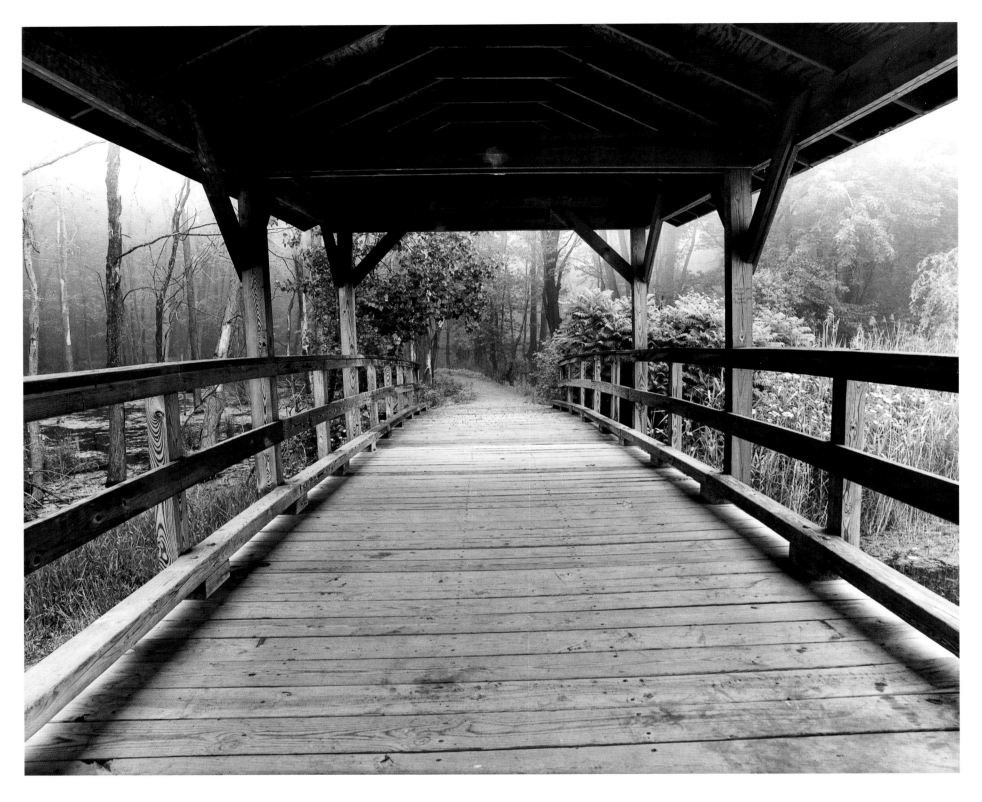

31 ❧ *Covered Bridge*
WALLED LAKE

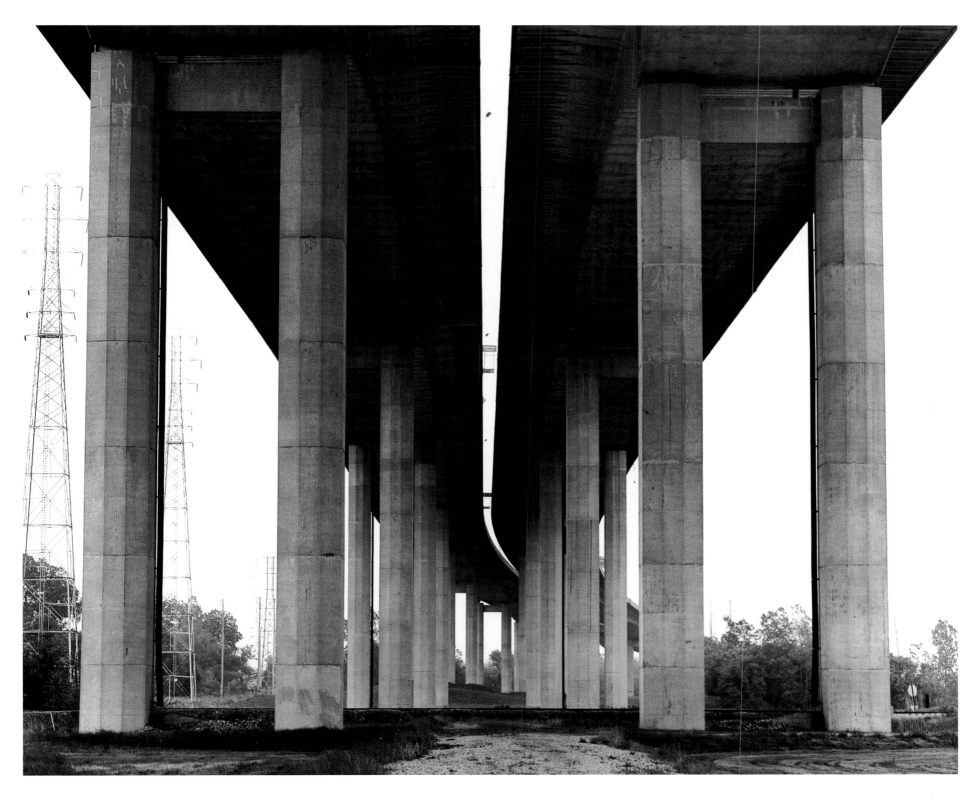

32 ❧ *Beneath the Zilwaukee Bridge*
ZILWAUKEE

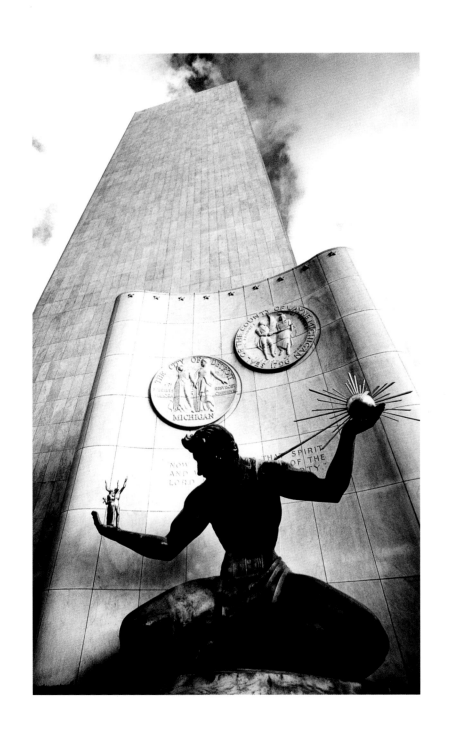

33 ❧ *Spirit of Detroit*
DETROIT

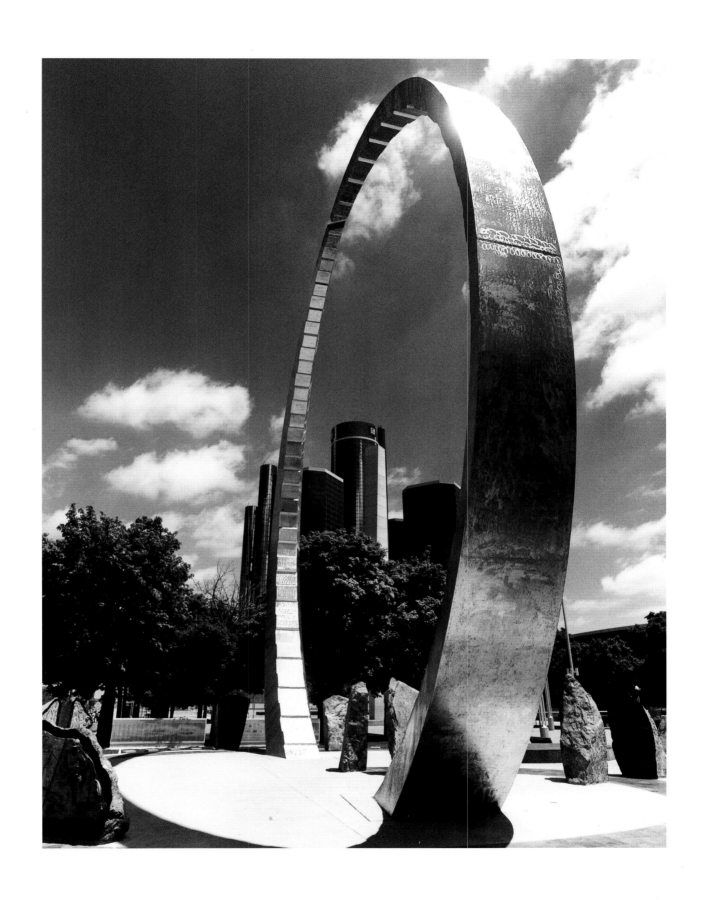

34 ❧ *"Transcending," Hart Plaza*
DETROIT

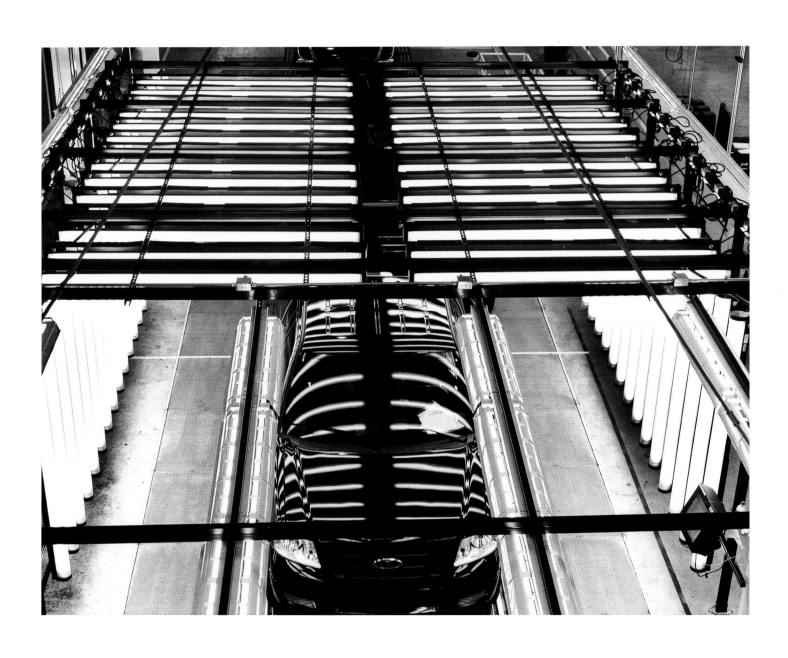

35 🦌 *Final Assembly, the Rouge*
DEARBORN

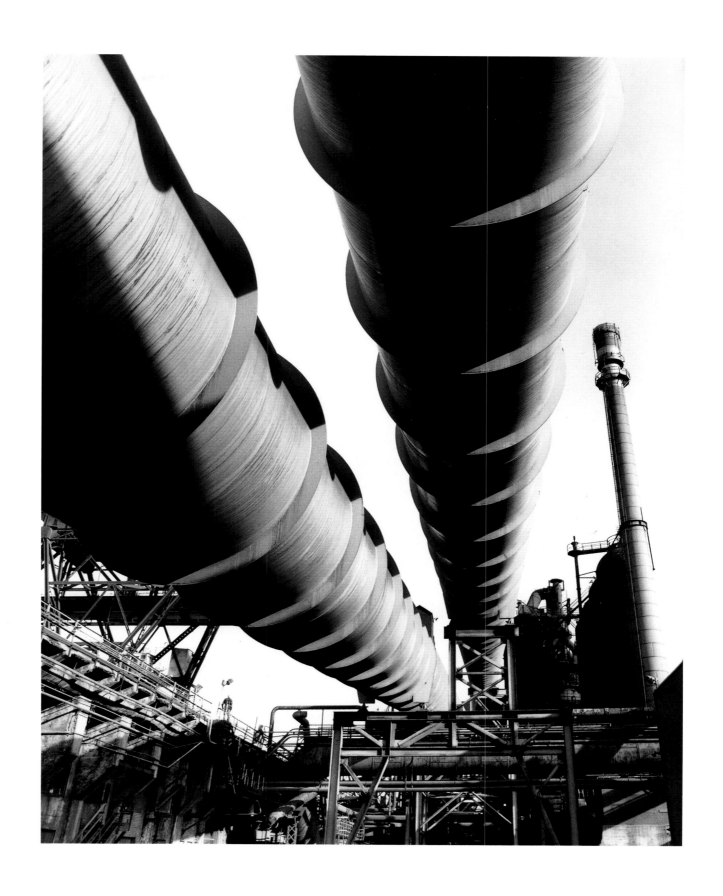

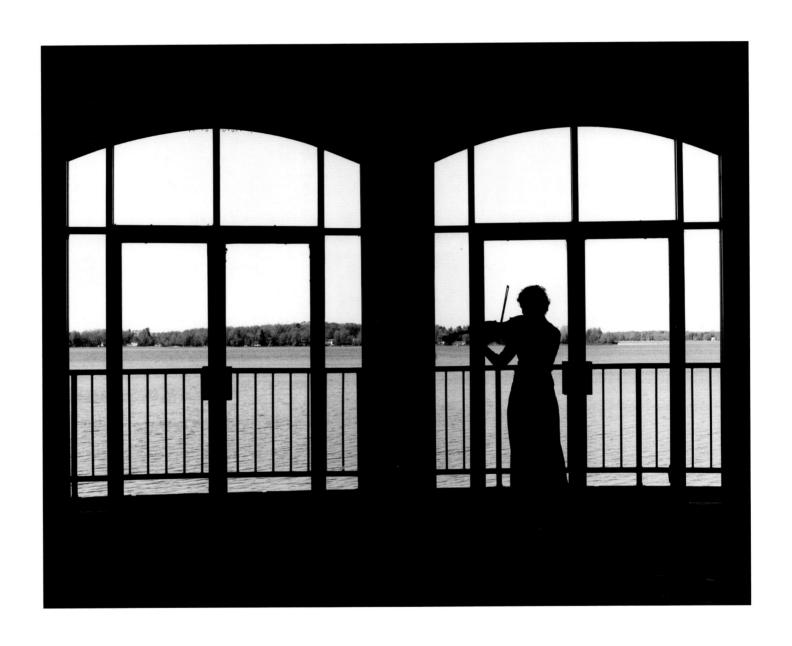

❧ *The Violist*
INTERLOCHEN

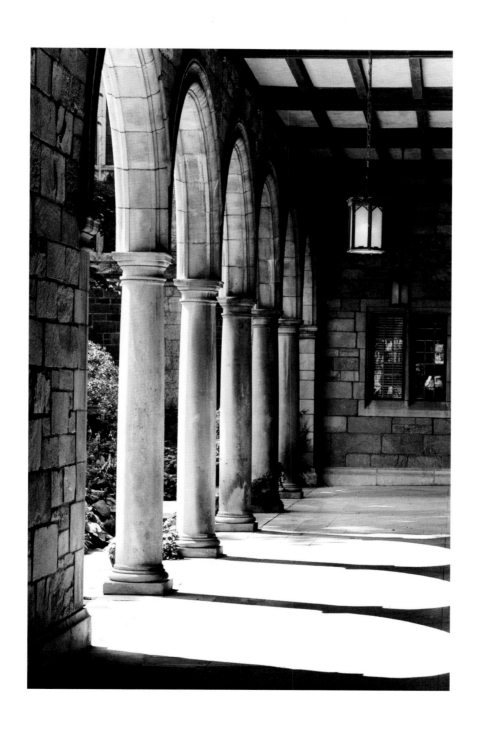

38 ❧ *Columns in the Law Quad*
ANN ARBOR

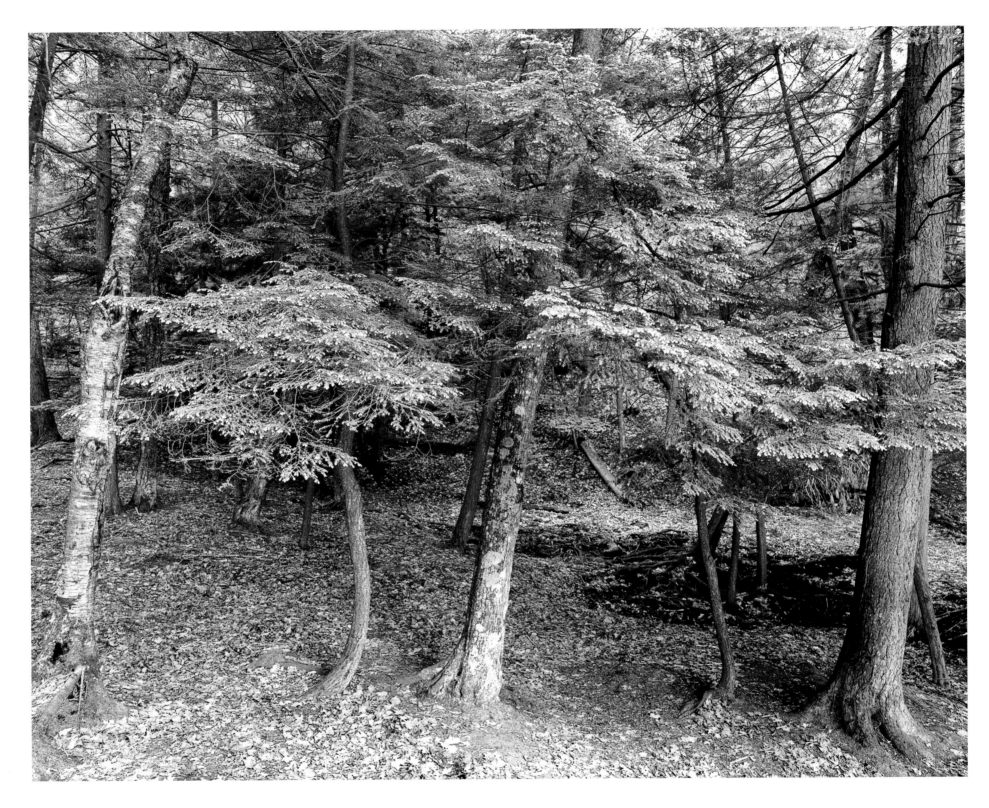

39 ❧ *Forest Floor at Iargo Springs*
HURON-MANISTEE NATIONAL FOREST,
OSCODA

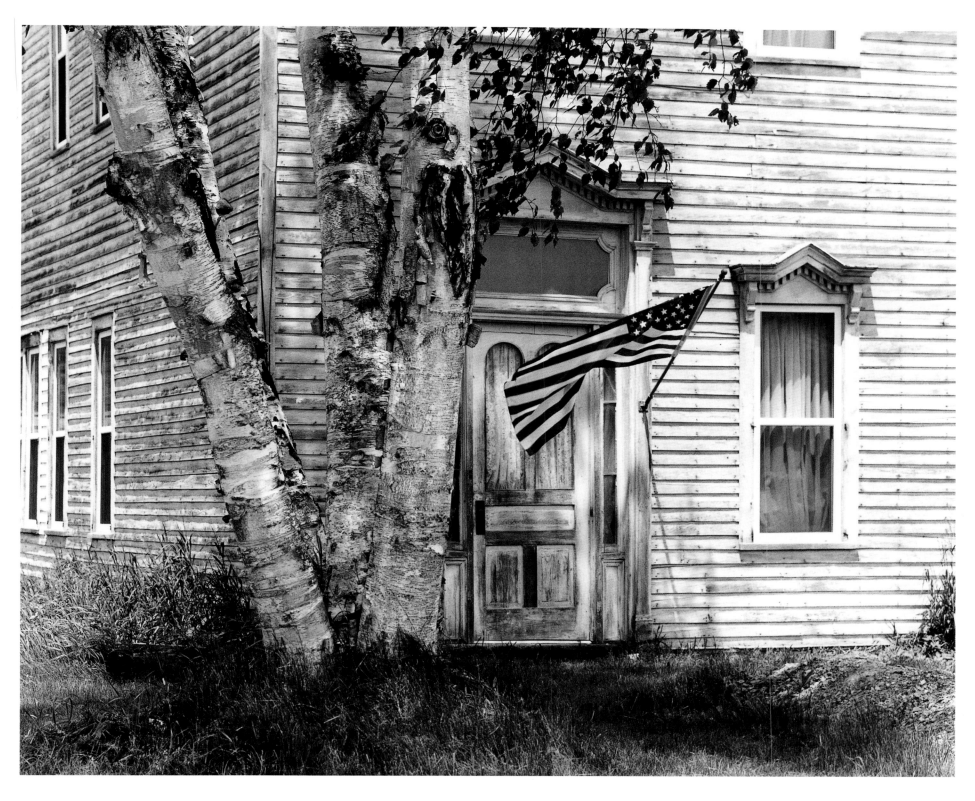

40 ❧ *Old House & Flag*
OMER

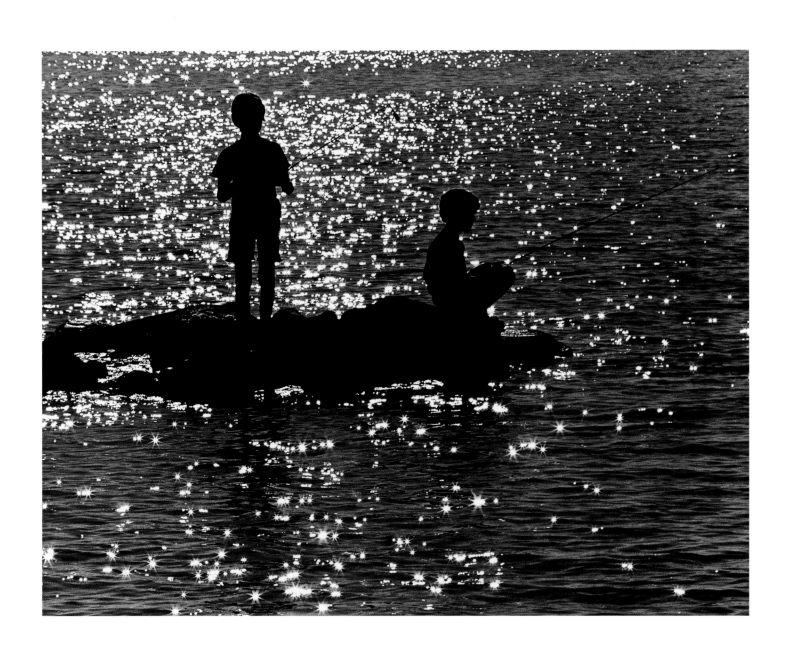

41 *Two Boys Fishing*
NORTHPORT

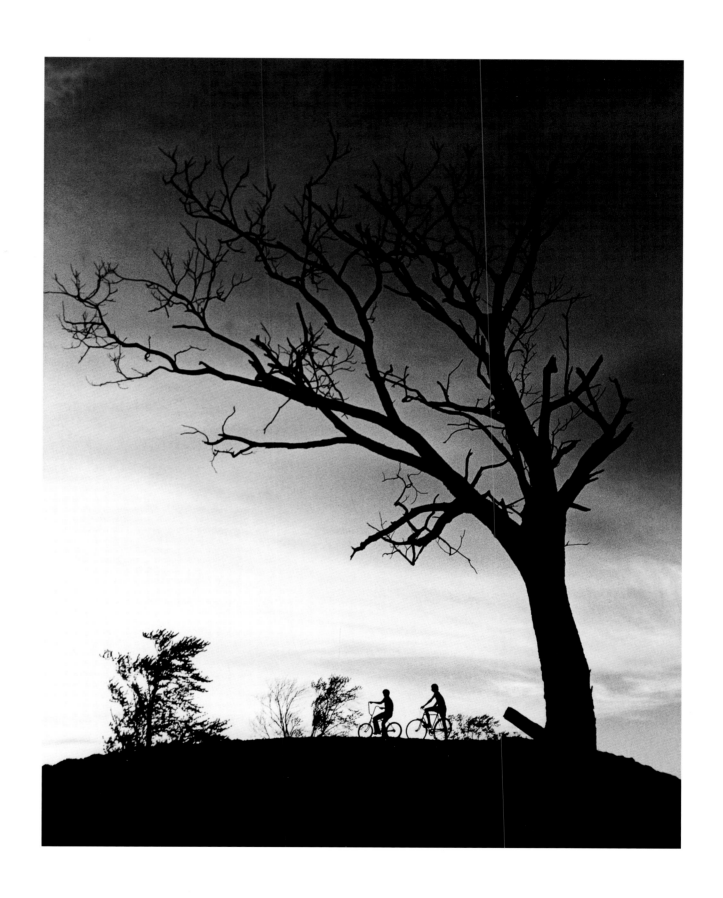

❧ *Riding Bikes*
TROY

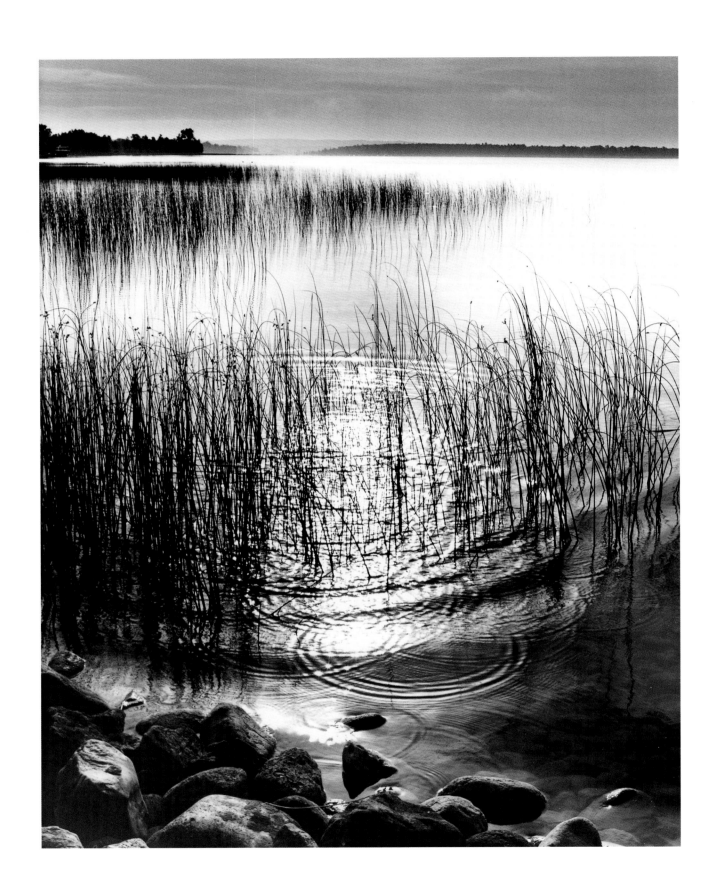

43 ❦ *Reeds & Ripples*
CONWAY

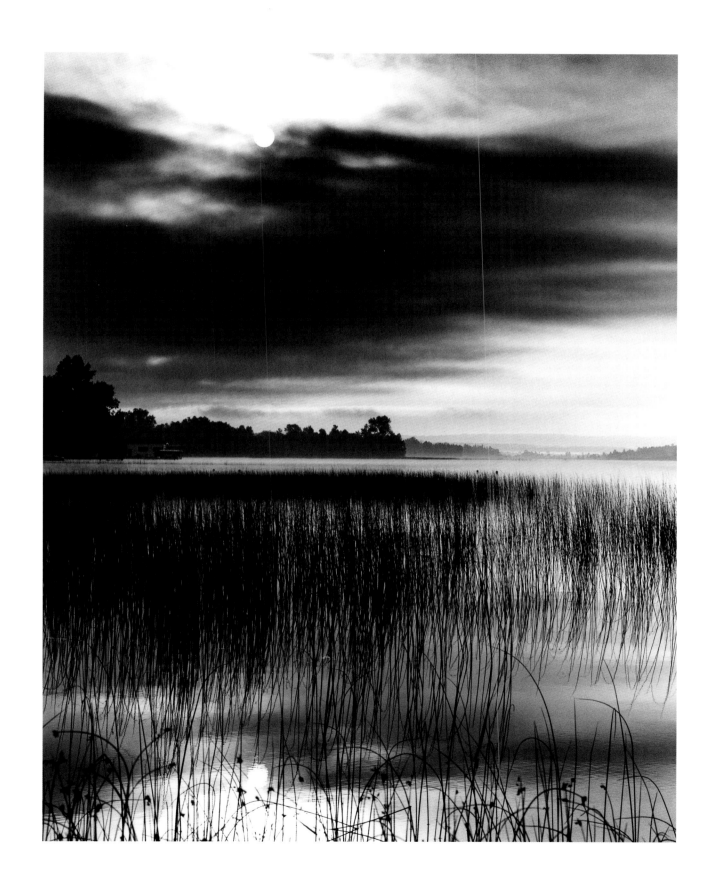

44 �*/Sunrise at Crooked Lake*
CONWAY

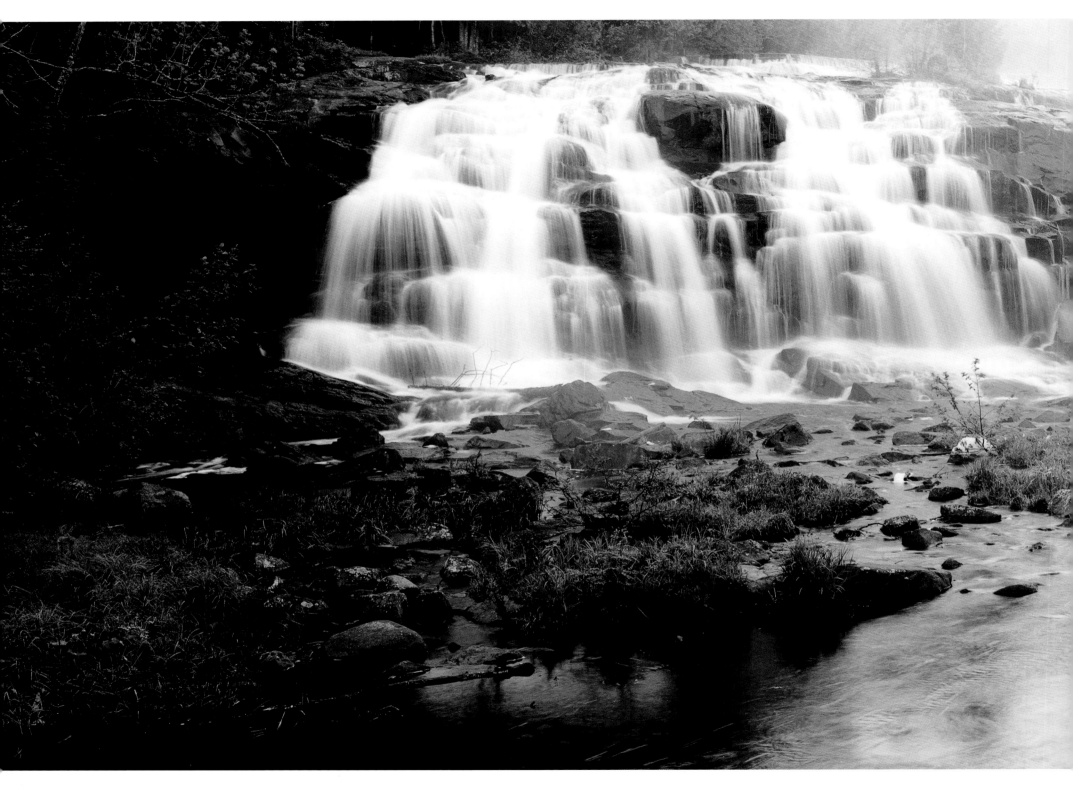

45 ❧ *Lower Bond' Falls*
BRUCE CROSSING

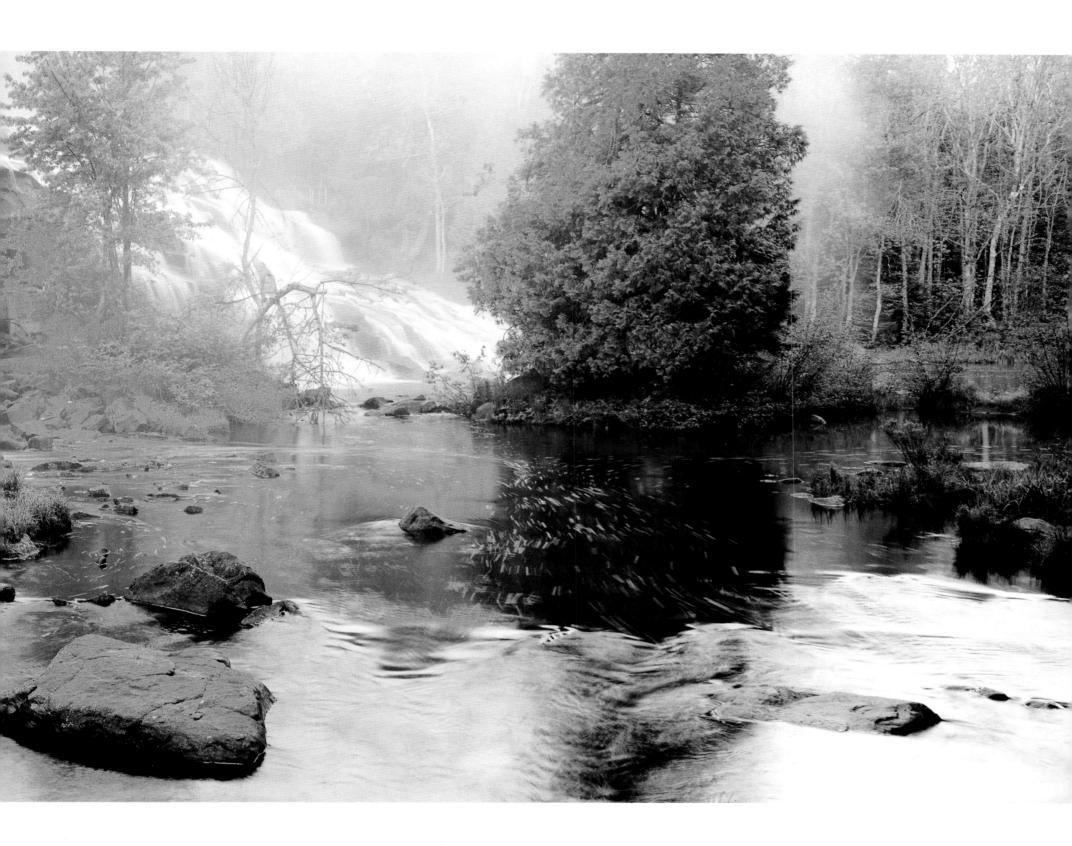

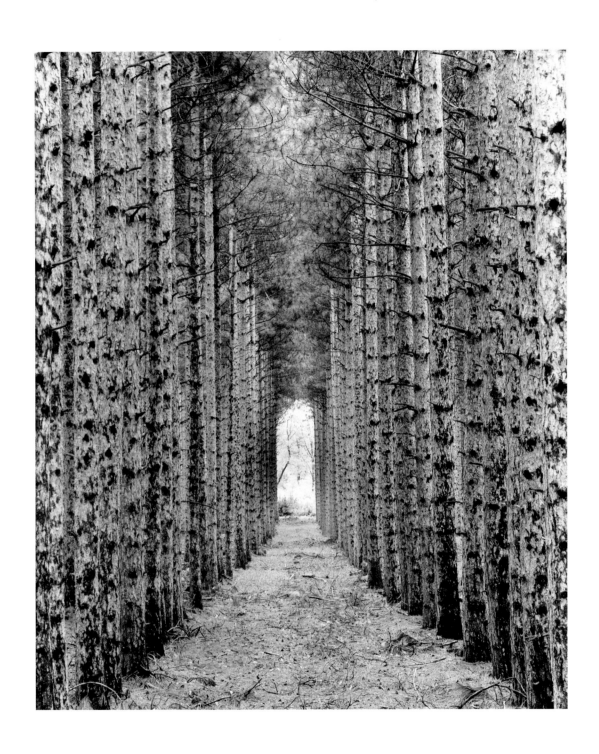

46 ❧ *Red Pines*

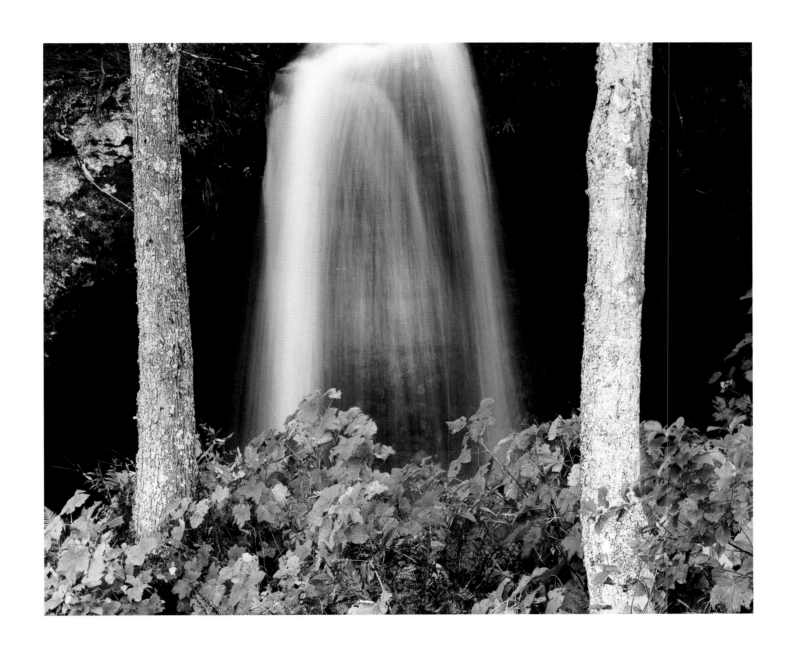

47 ❧ *Scott Falls*
MUNISING

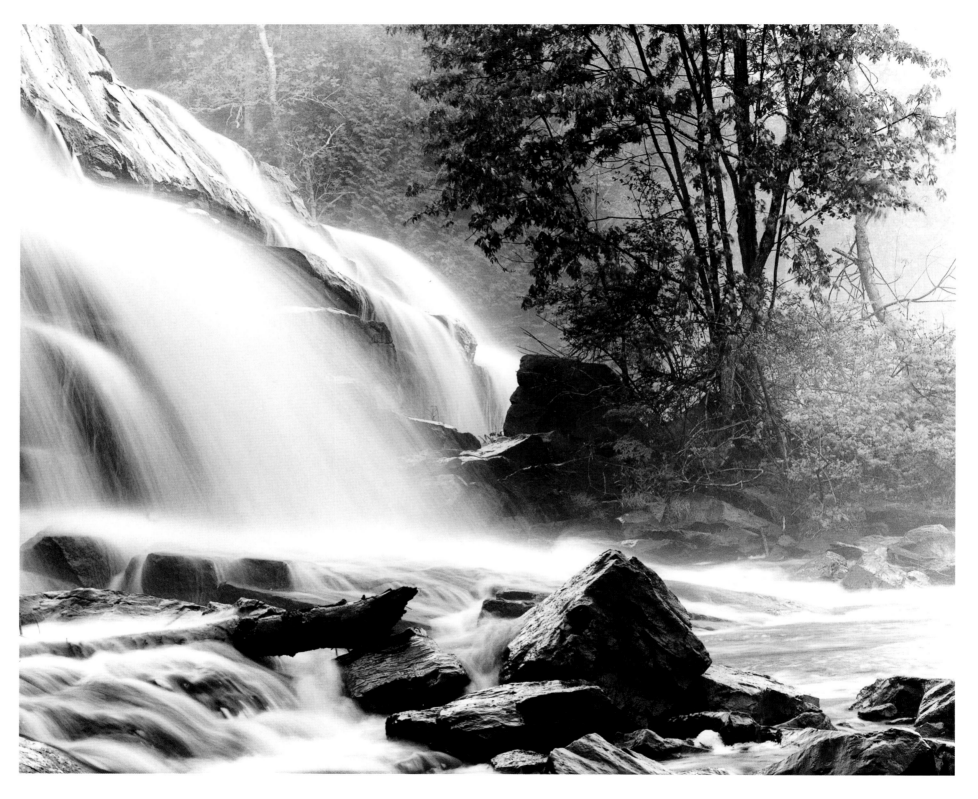

48 ❧ *Falls, Trees & Rocks*
BRUCE CROSSING

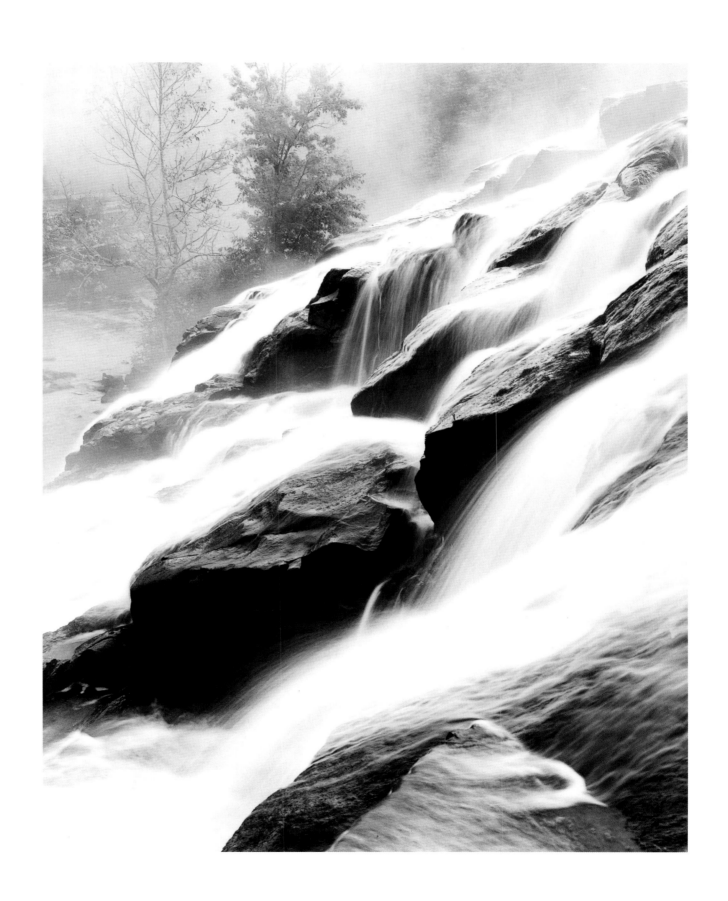

49 ❧ *Cascades of Bond Falls*
BRUCE CROSSING

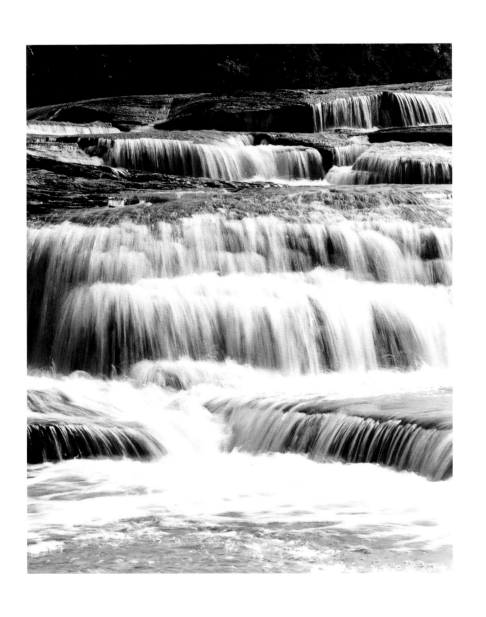

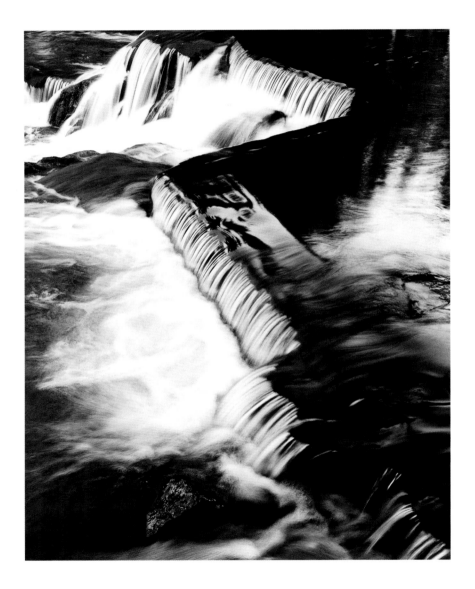

50 ❧ *Madino Falls*
PRESQUE ISLE

51 ❧ *Detail of Bond Falls*
BRUCE CROSSING

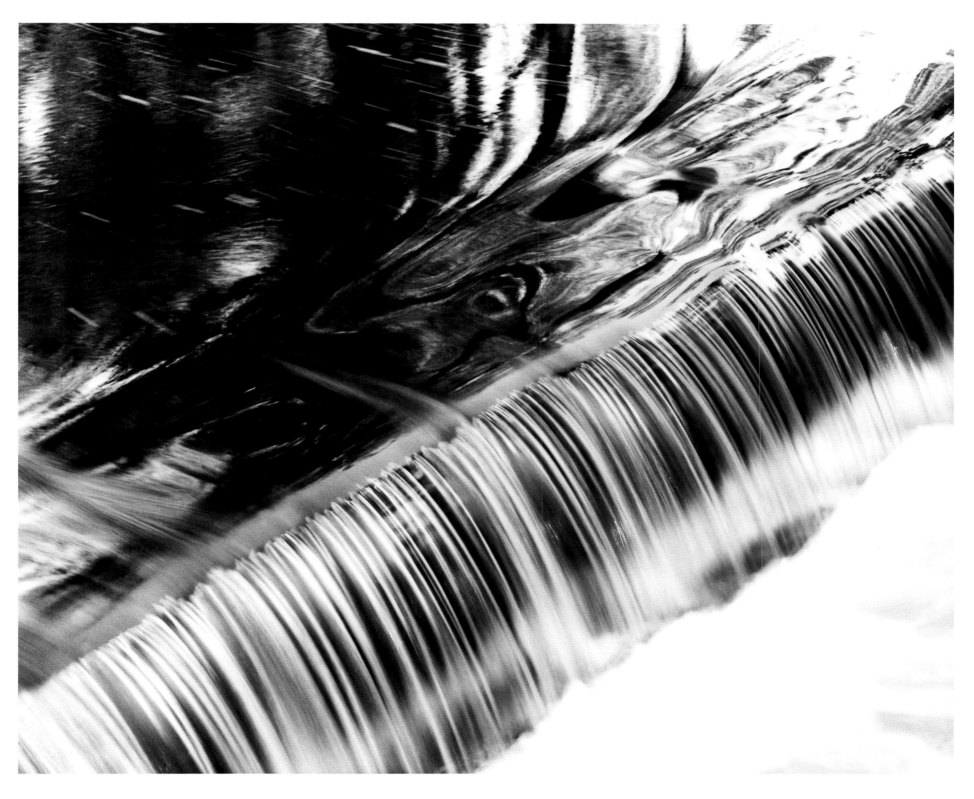

52 ❧ *Waterfall Abstract*
BRUCE CROSSING

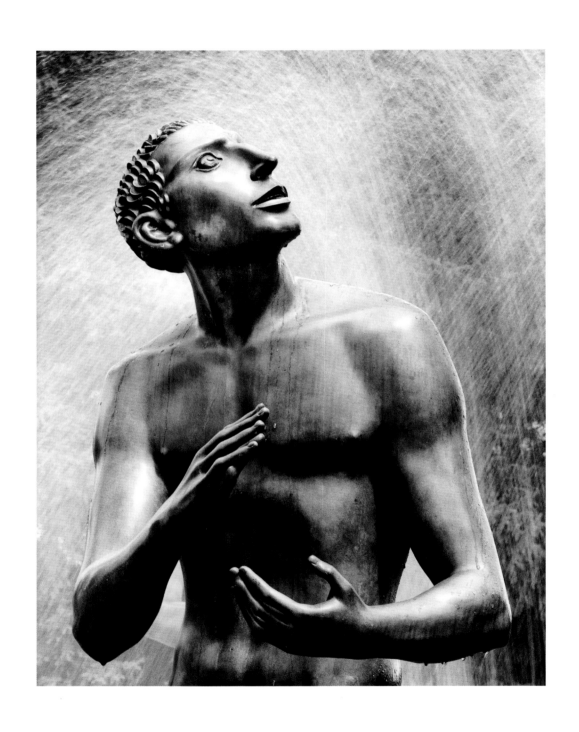

53 🌿 *Orpheus*
CRANBROOK GARDENS,
BLOOMFIELD HILLS

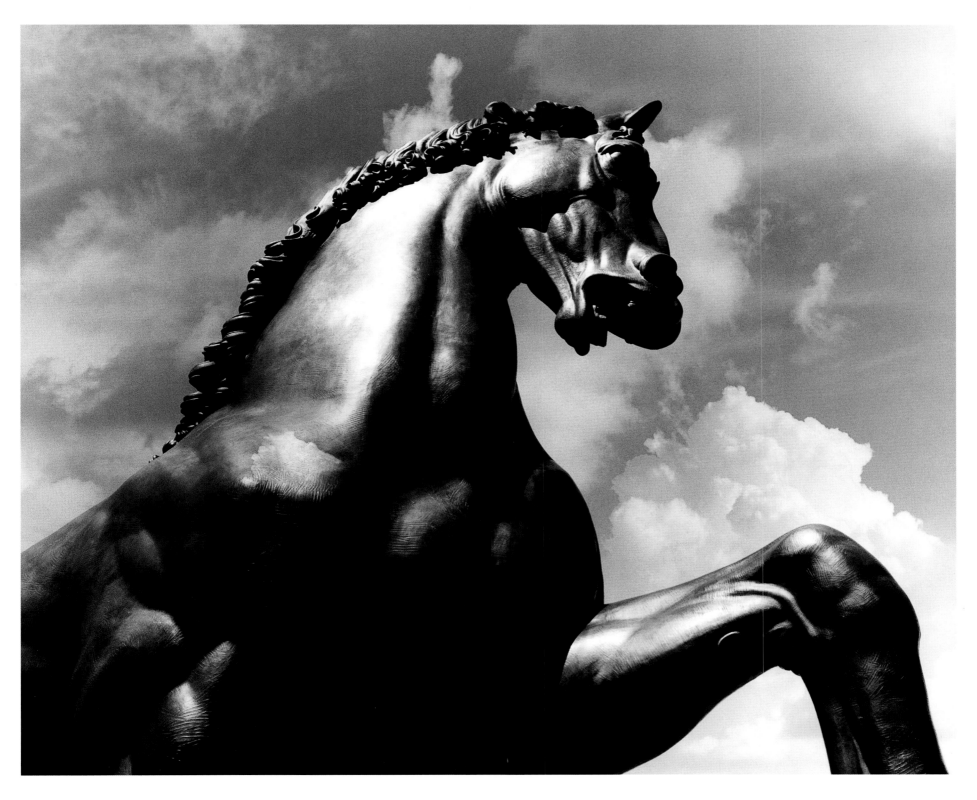

54 ❧ *Leonardo da Vinci's Horse: The American Horse*
FREDERIK MEIJER GARDENS & SCULPTURE PARK,
GRAND RAPIDS

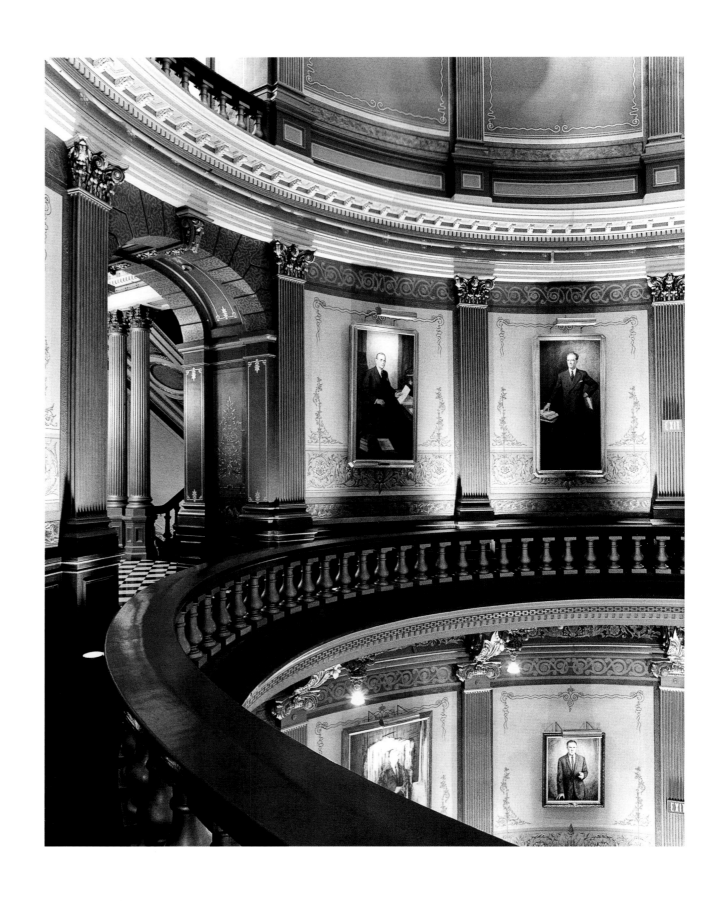

55 ❧ *State Capitol Interior*
LANSING

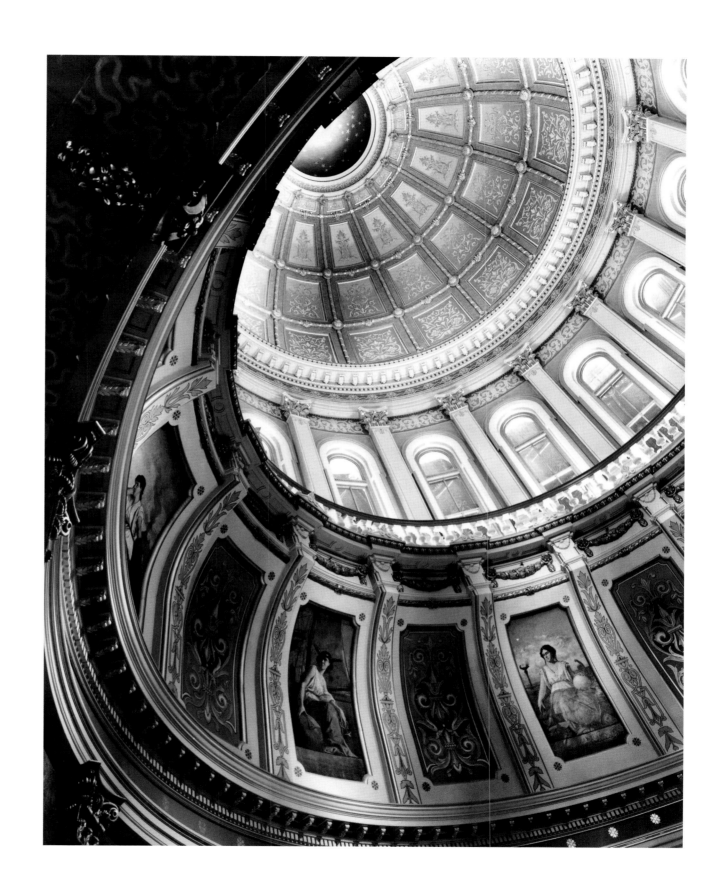

56 🍂 *Dome of the State Capitol*
LANSING

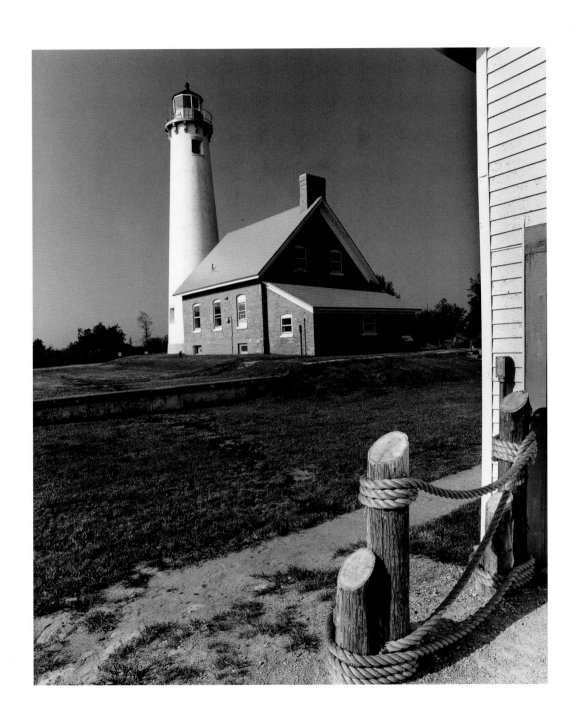

57 ❧ *Tawas Point Lighthouse*
TAWAS POINT STATE PARK

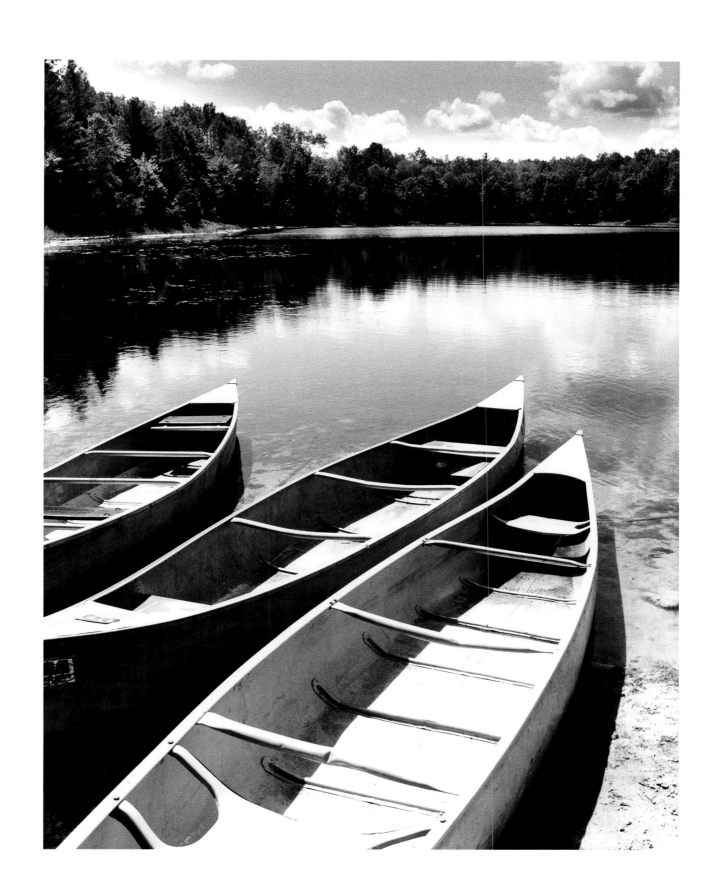

58 ❧ *Three Boats*
KALKASKA

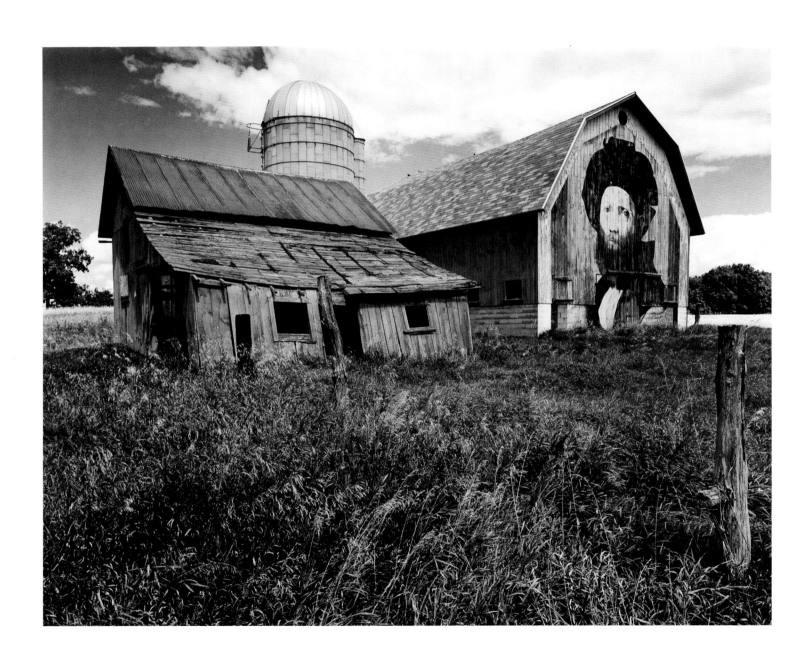

Raphael Barn,
59 🌿 *"Portrait of Baldassare Castiglione"*
HARTLAND

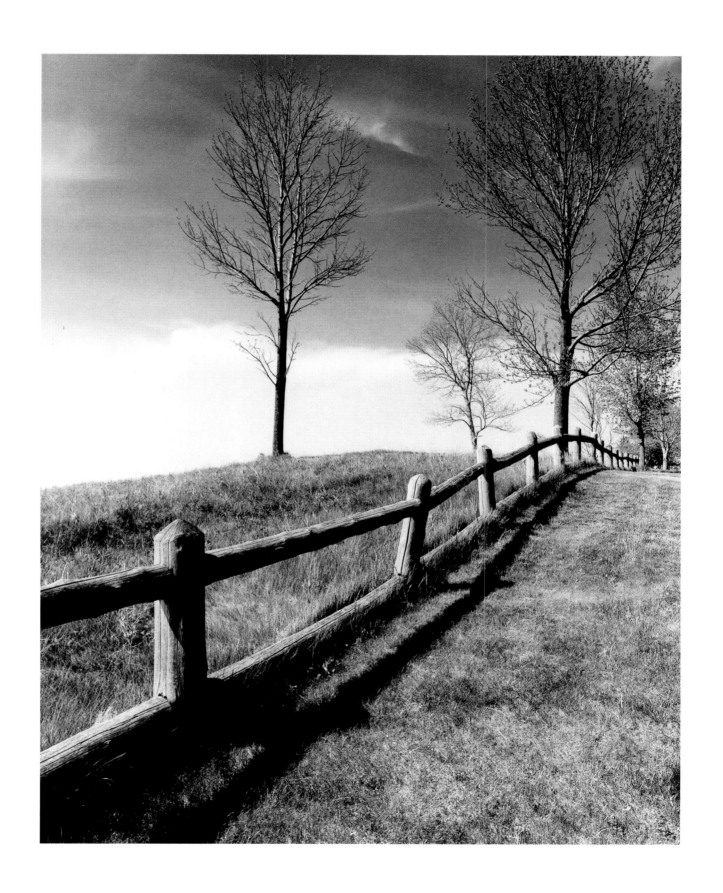

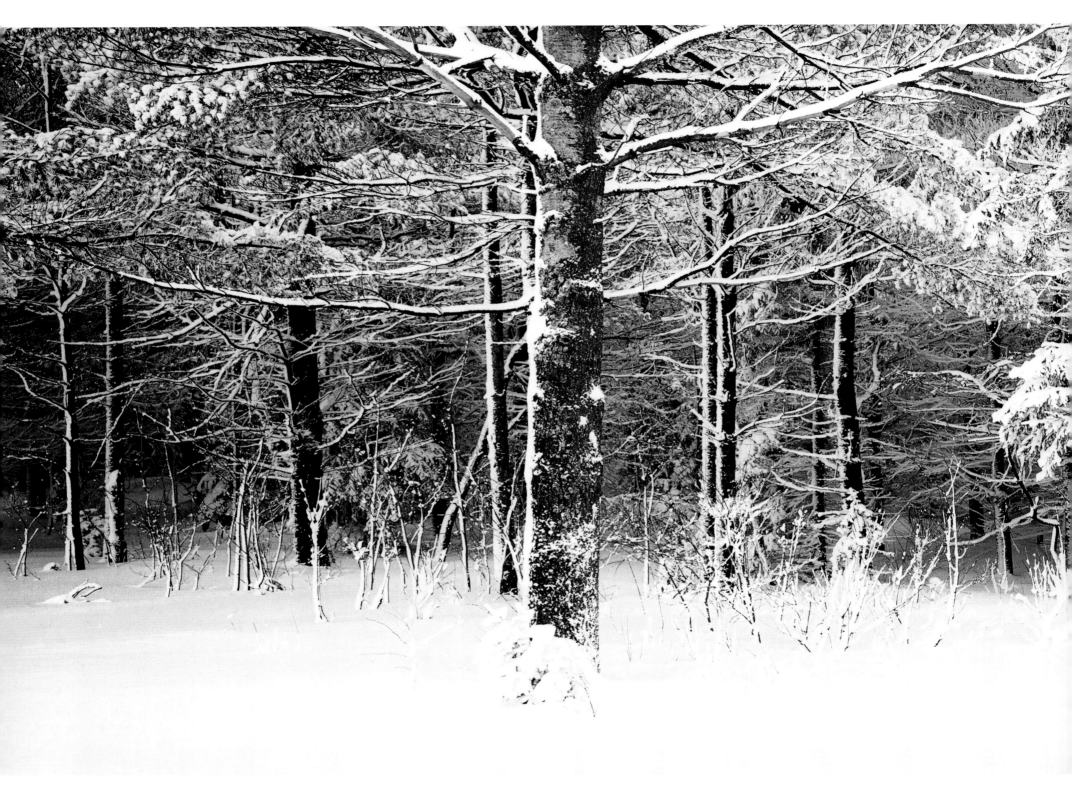

61 ❧ *Snow Etchings*

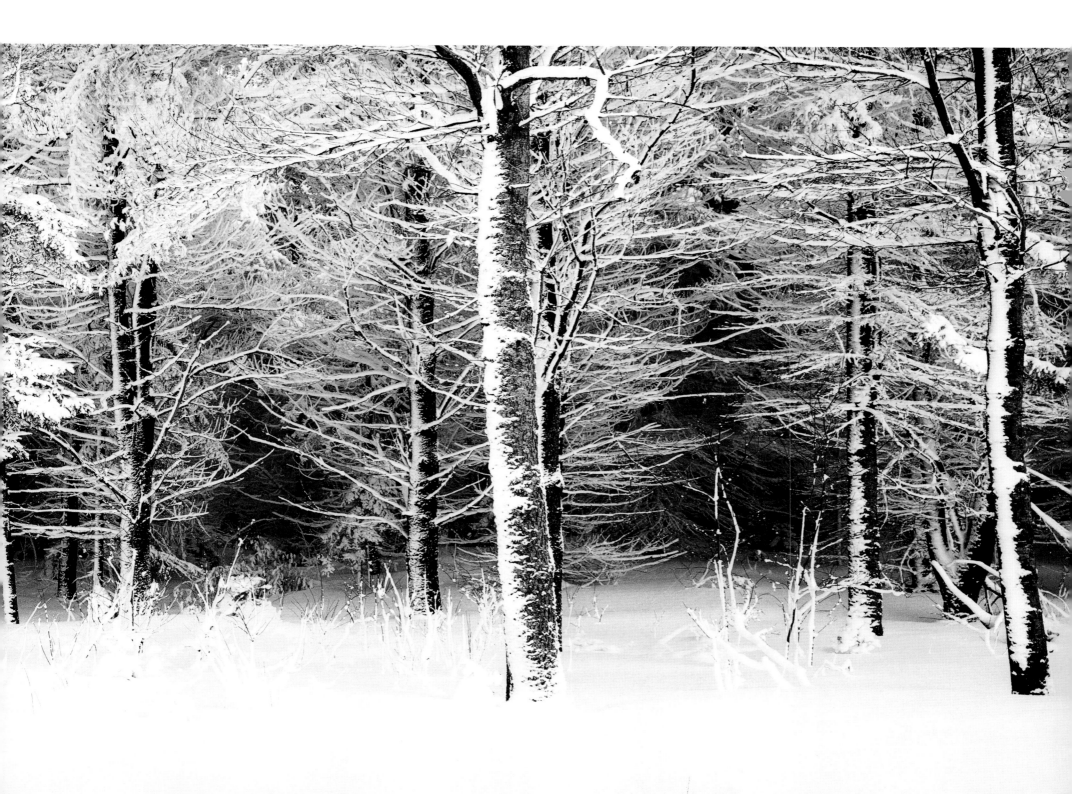

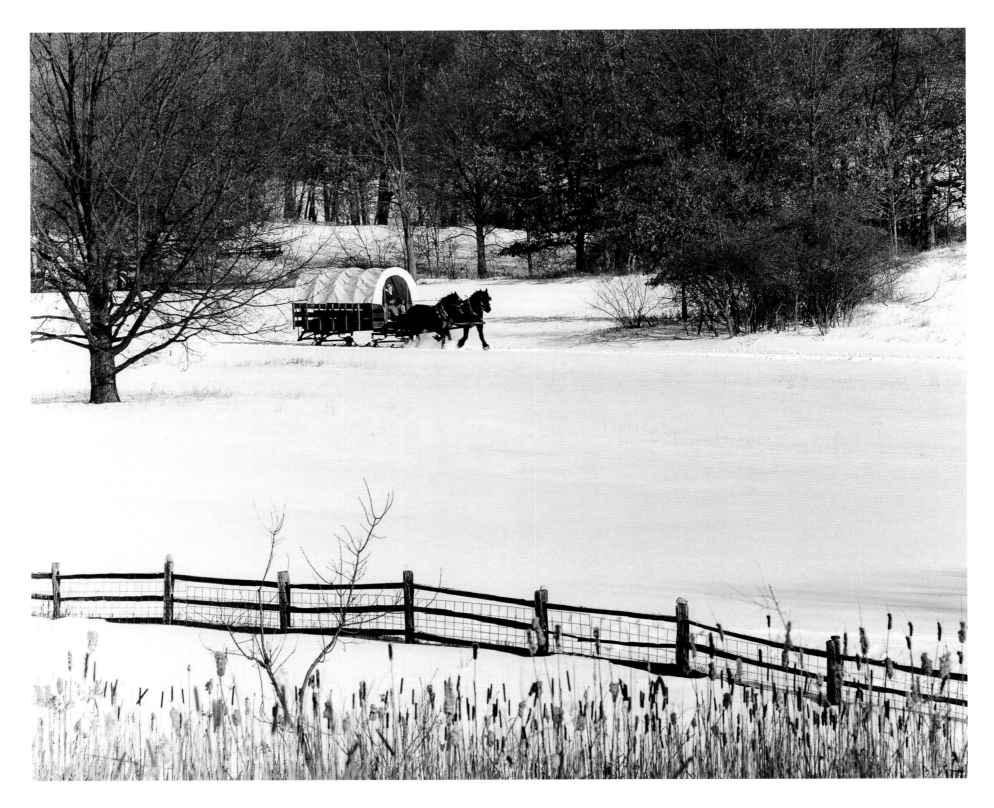

62 ❧ *Heading Home*

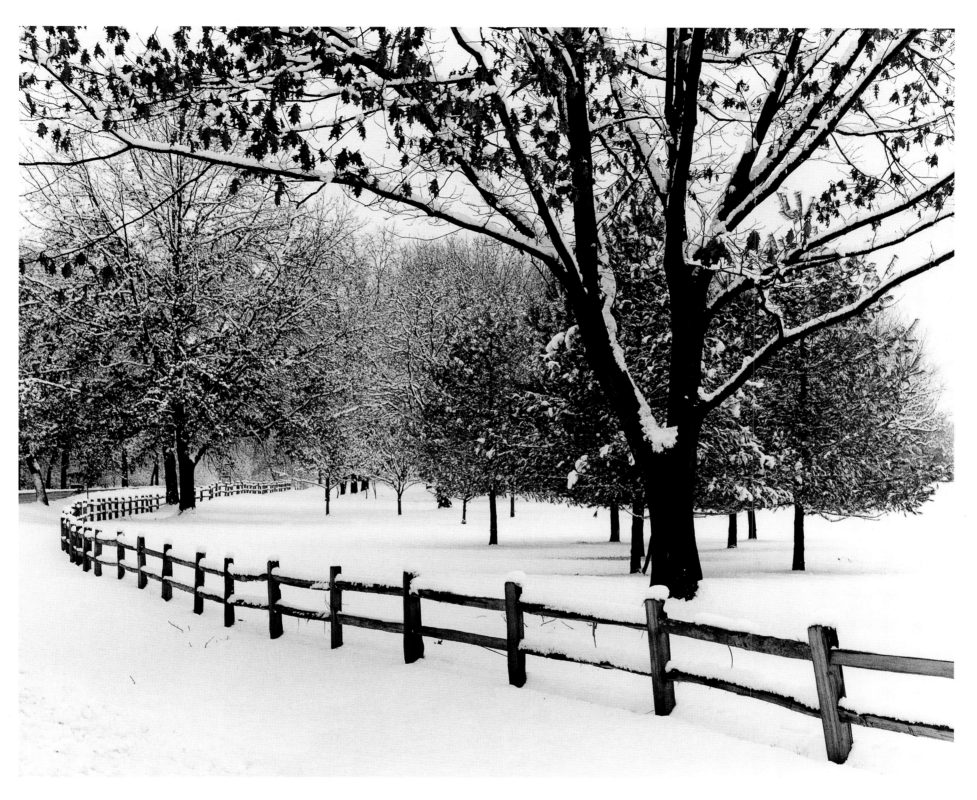

63 ❧ *Fence in Winter*
KENSINGTON METROPARK,
MILFORD

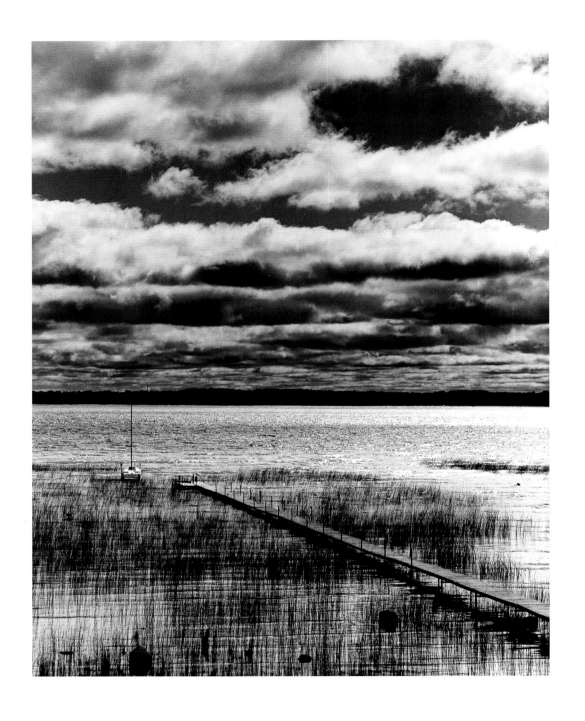

64 ❧ *Wooden Pier*
SUTTONS BAY

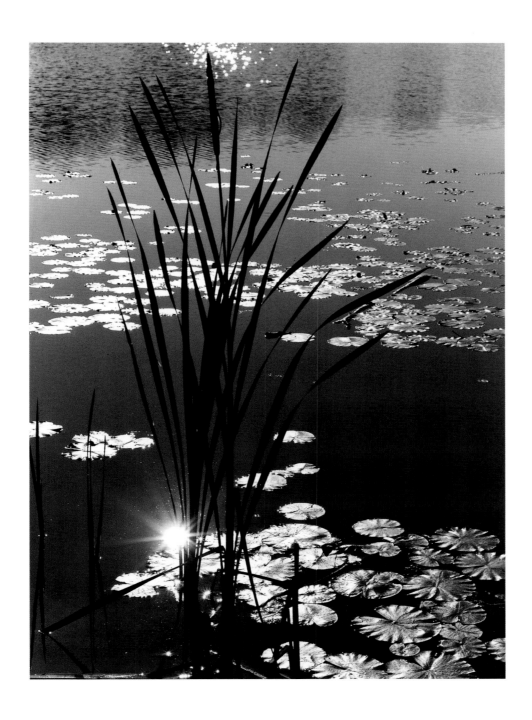

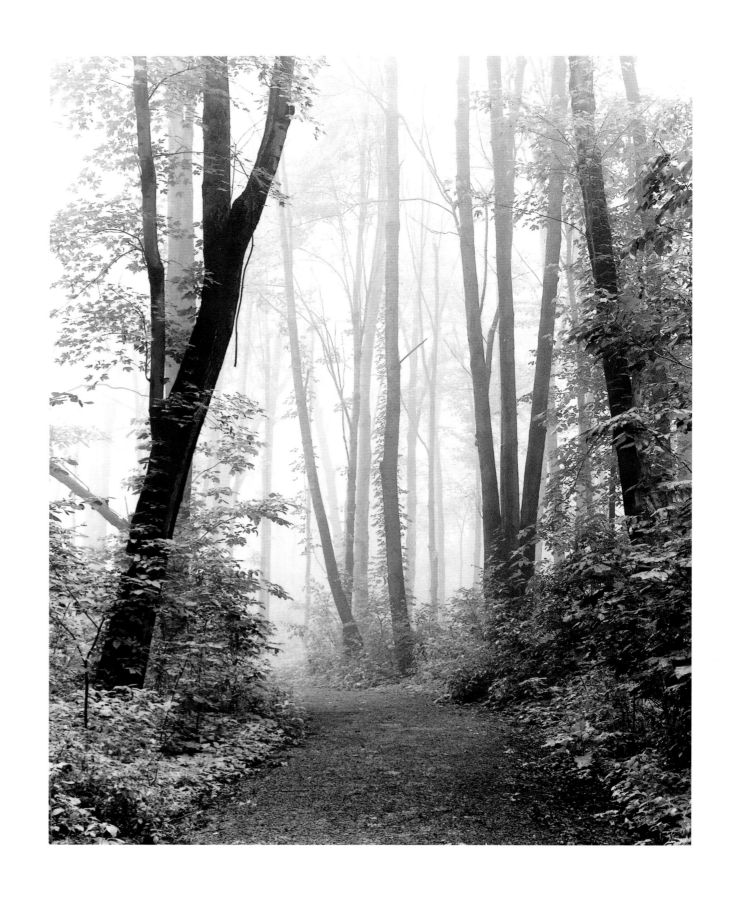

66 *Trees in the Mist*
WALLED LAKE

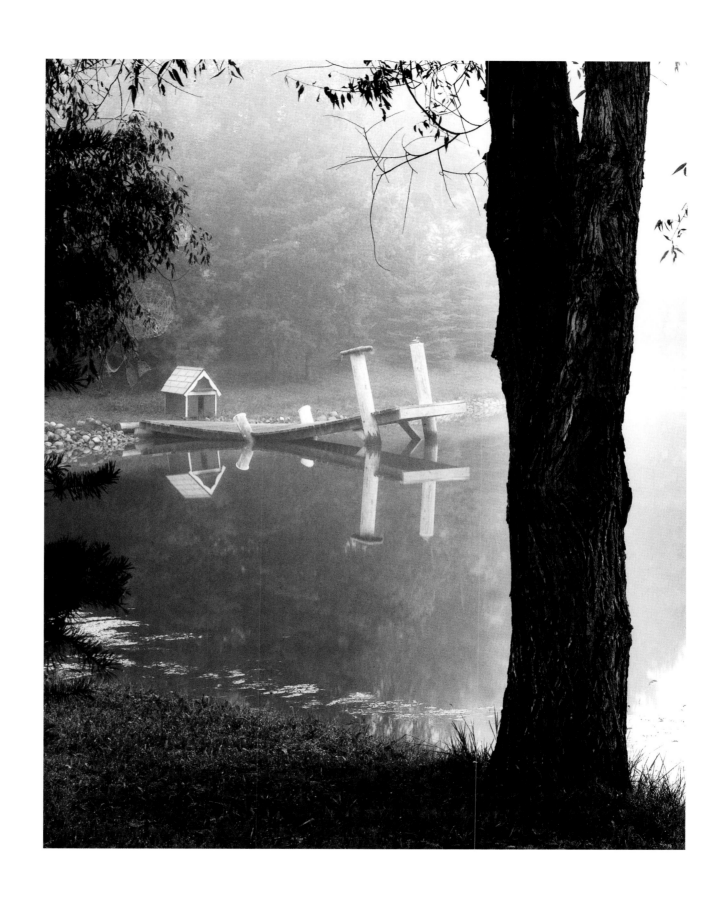

67 ❦ *Dock in the Mist*
WEST BRANCH

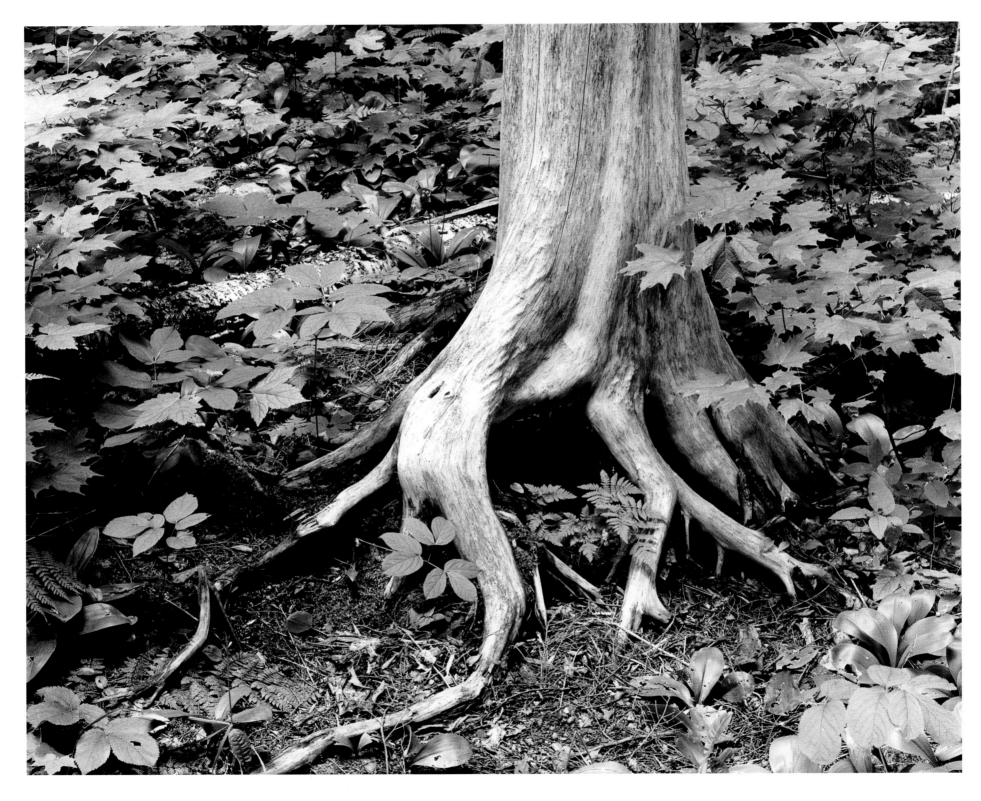

68 *Roots & Leaves*

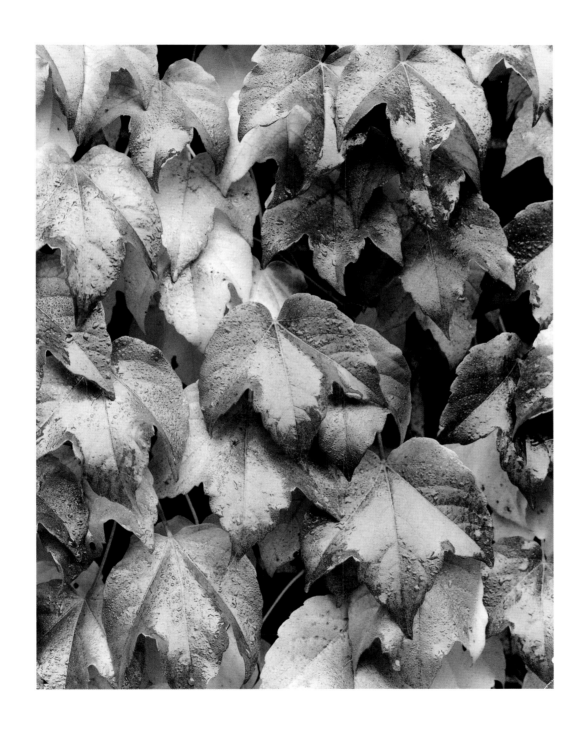

69 ❧ *Maple Leaves*
BLOOMFIELD HILLS

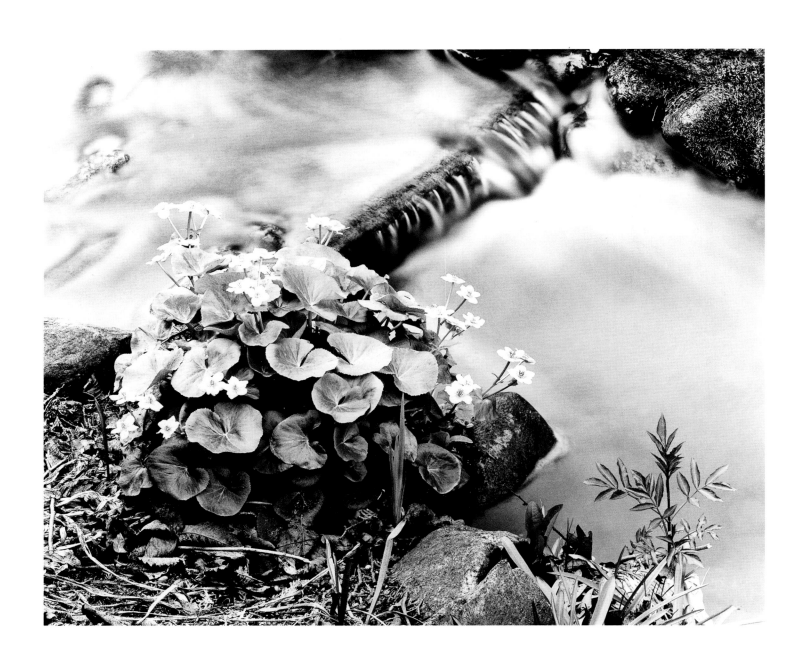

70 *Marsh Marigolds*
BLOOMFIELD HILLS

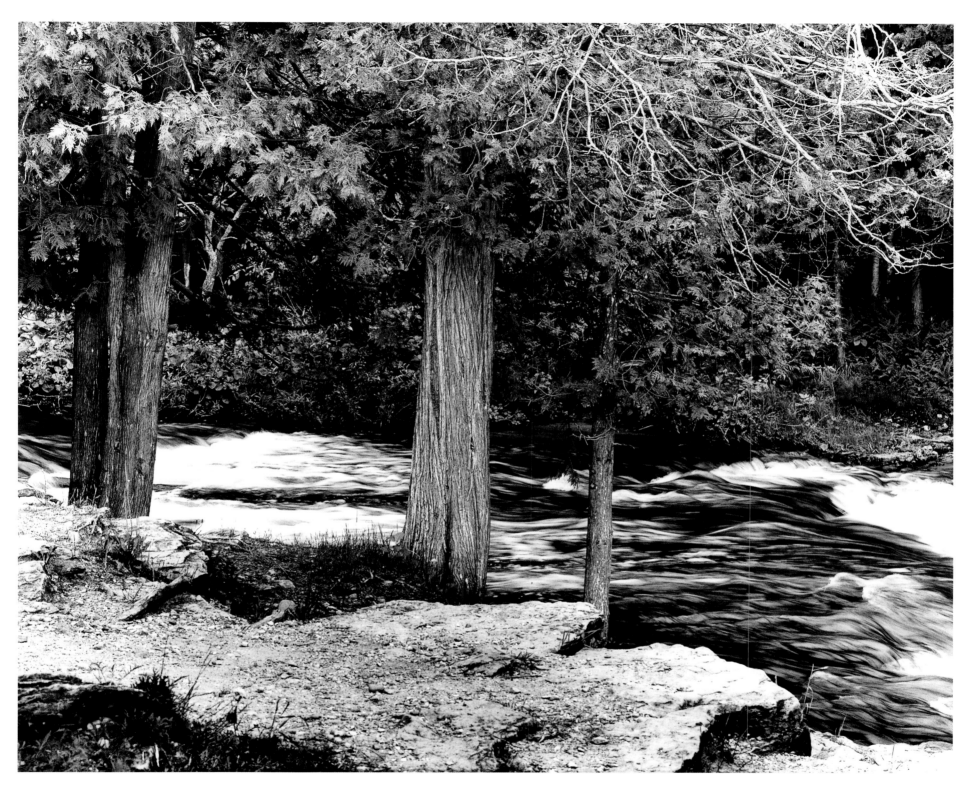

71 ❧ *River at Ocqueoc Falls*
OCQUEOC

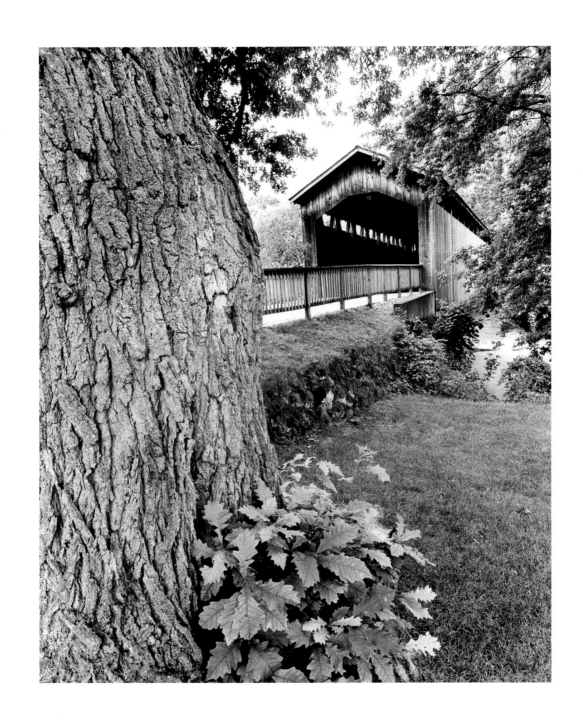

72 ❧ *Covered Bridge*
ADA

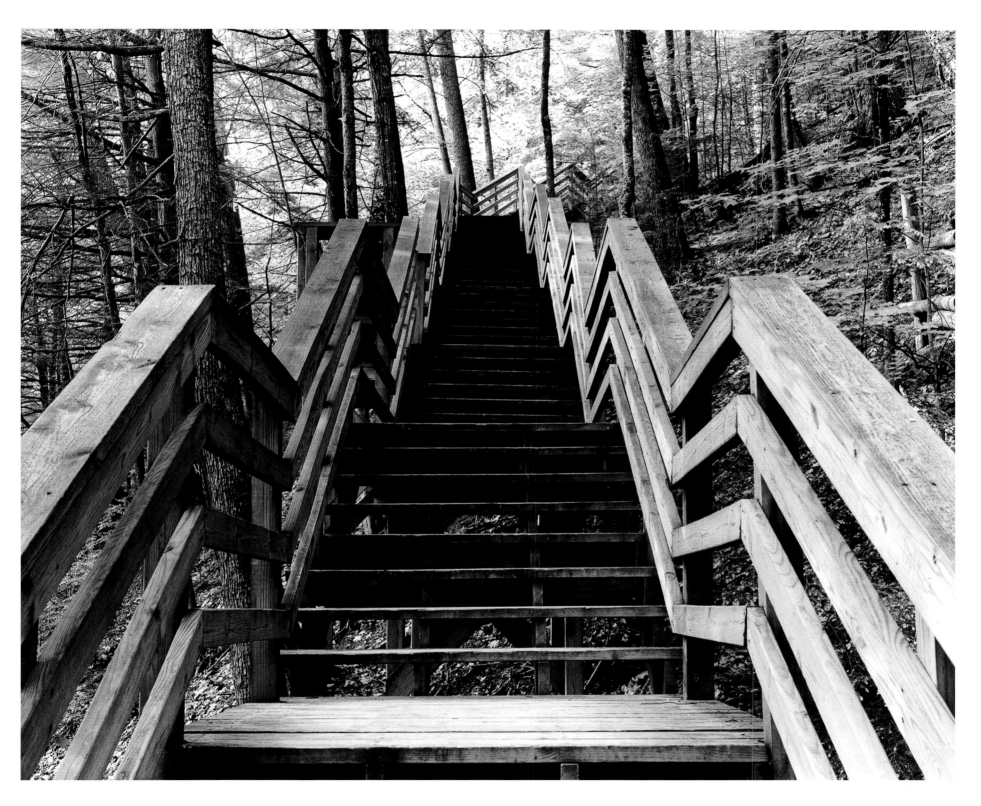

73 ❧ *Wooden Stairs at Iargo Springs*
HURON-MANISTEE NATIONAL FOREST,
OSCODA

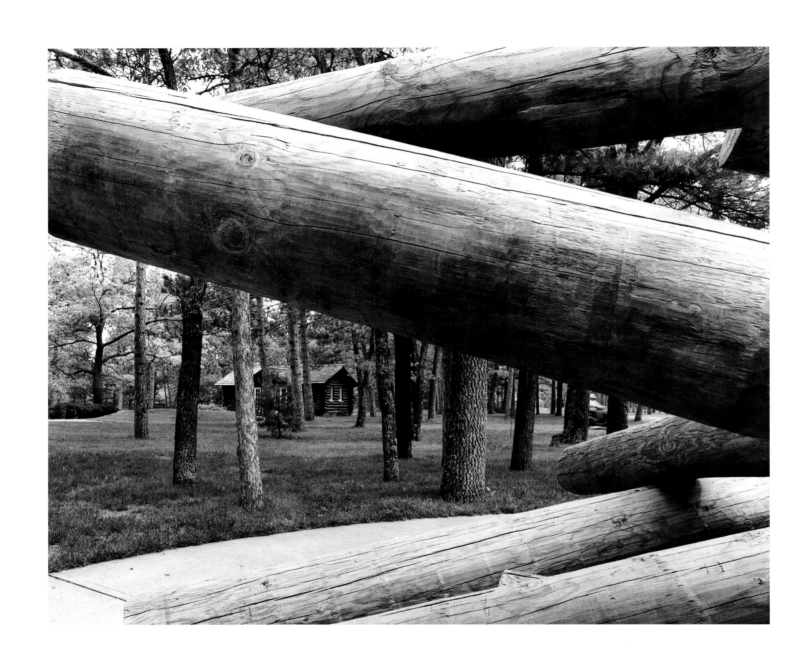

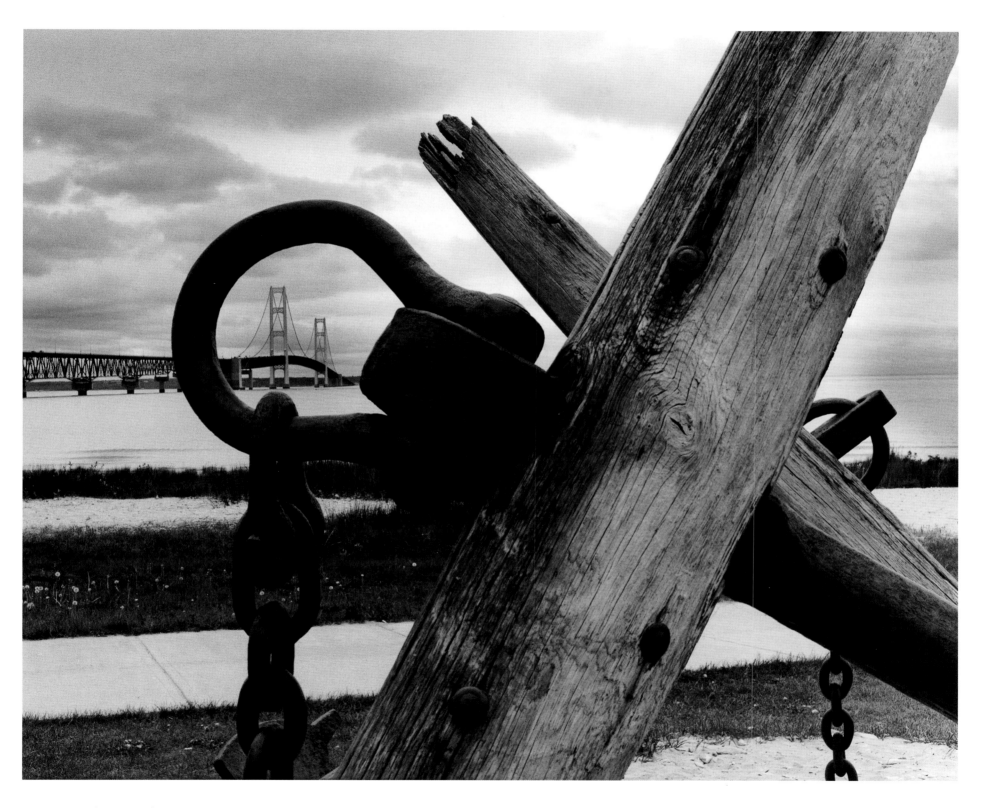

75 ❧ *Mackinac Bridge*
MACKINAW CITY

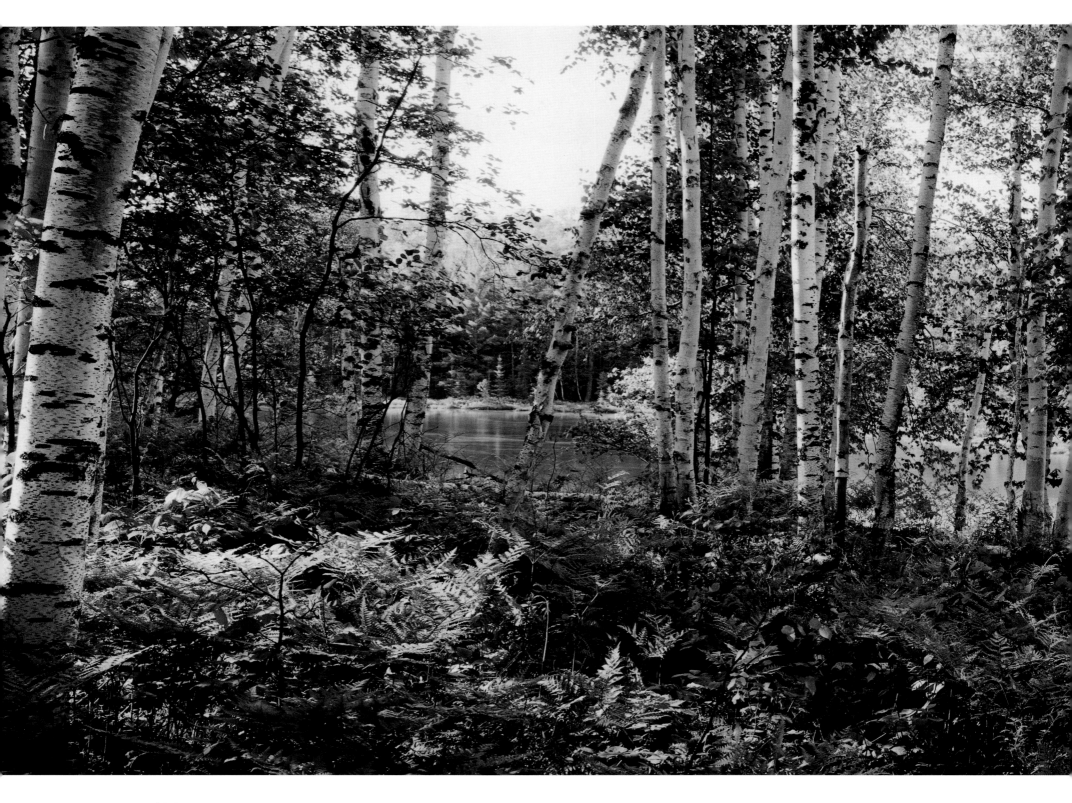

76 ❧ *Birch Trees*
ESCANABA RIVER STATE FOREST

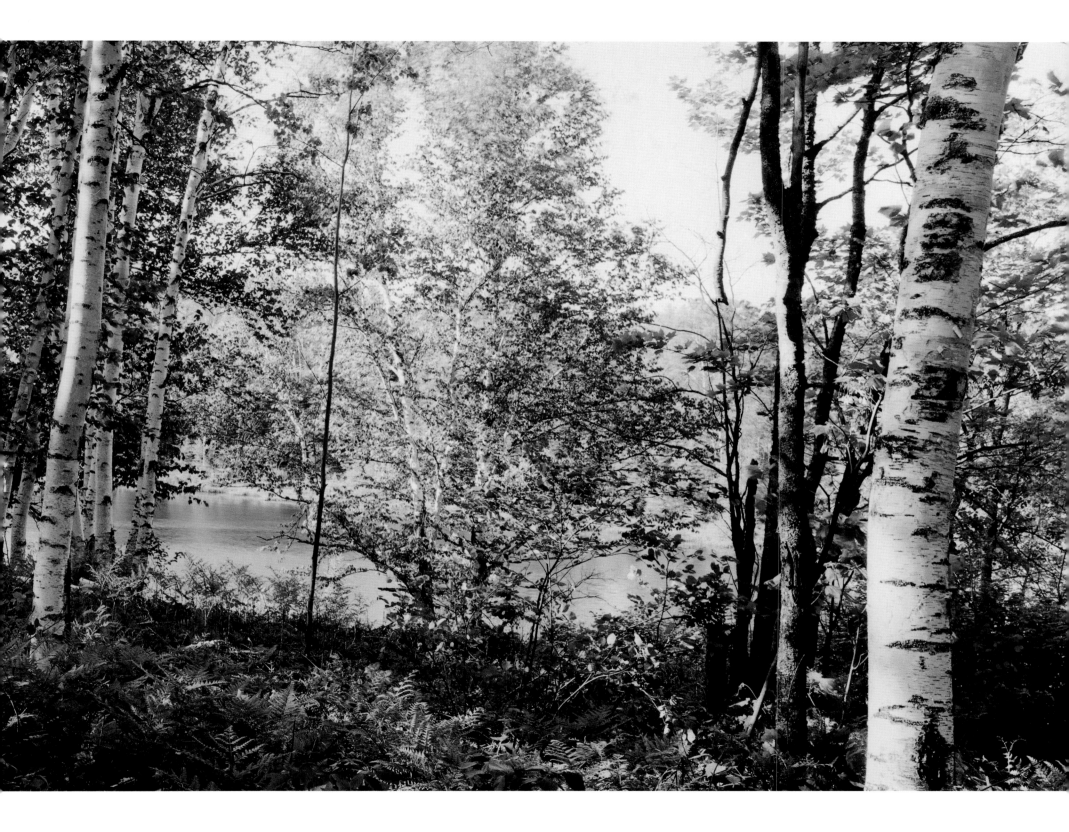

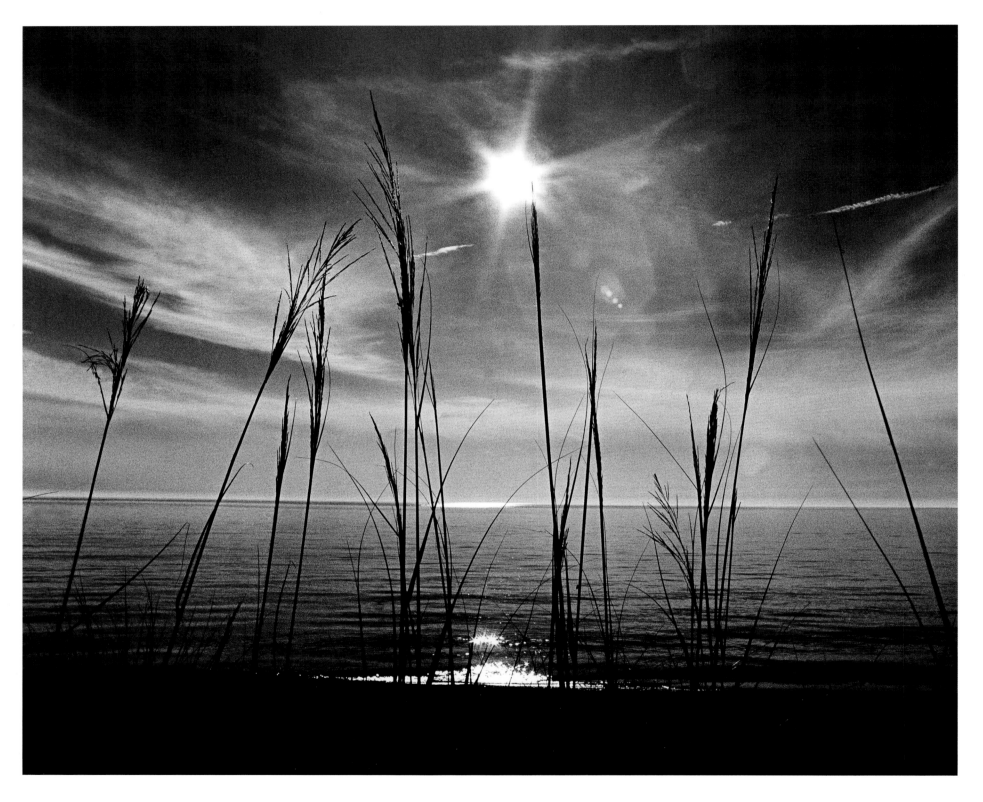

77 ❧ *Lake Michigan Sunset*
SOUTH HAVEN

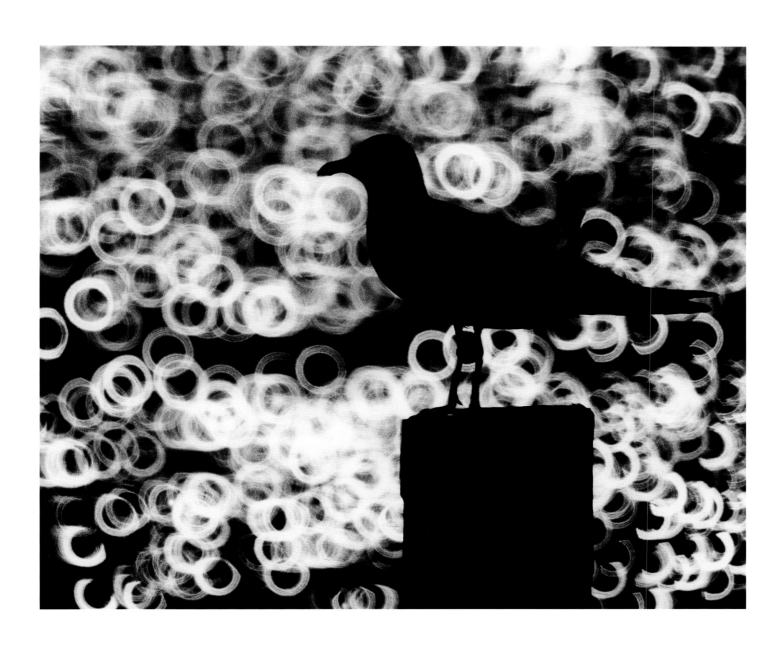

78 ❧ *Seagull Silhouette*
SAUGATUCK

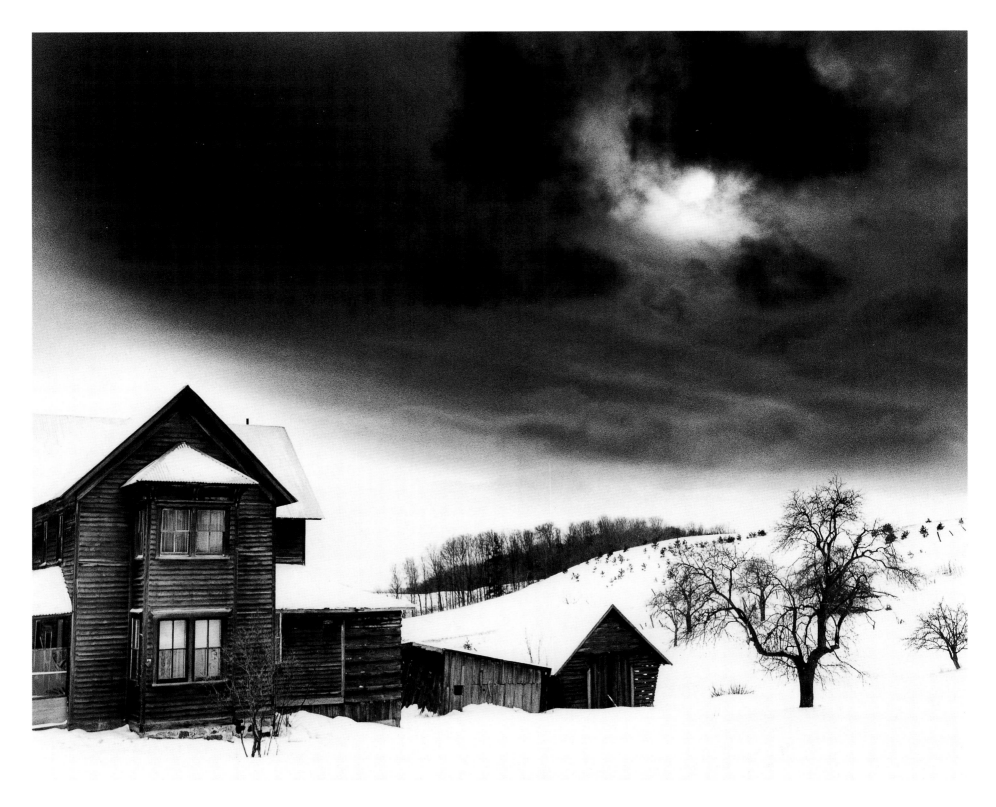

79 ❦ *Winter Storm*
BEULAH

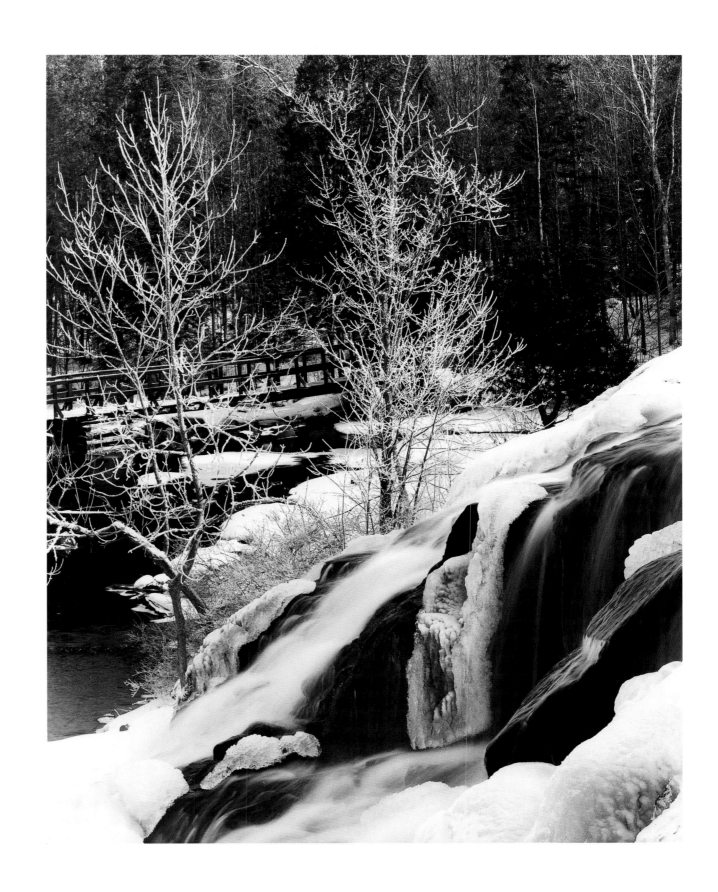

80 ❧ *Winter at Bond Falls*
BRUCE CROSSING

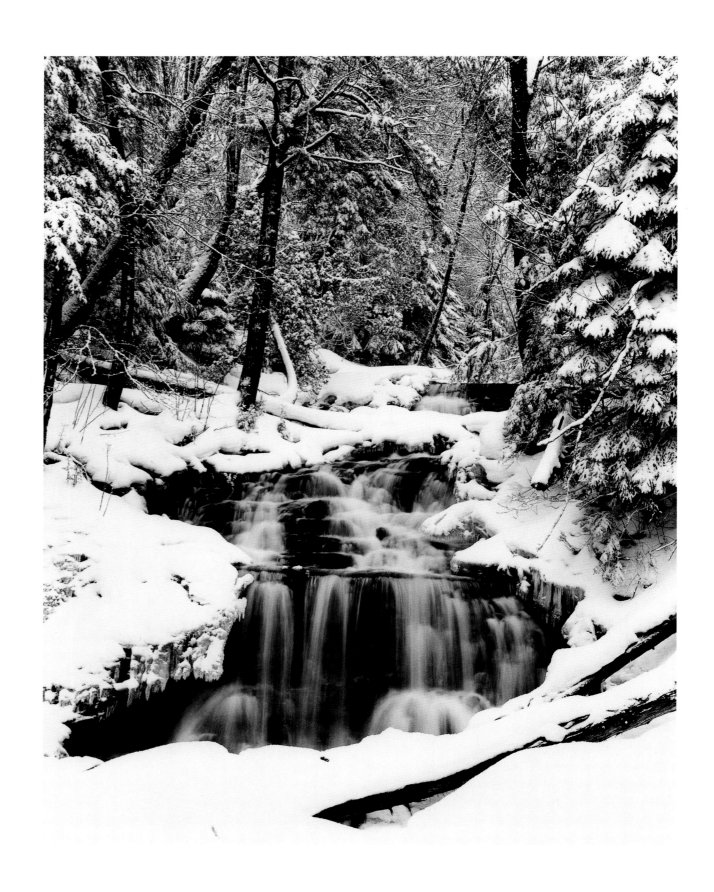

81 ❦ *Winter at Wagner Falls*
MUNISING

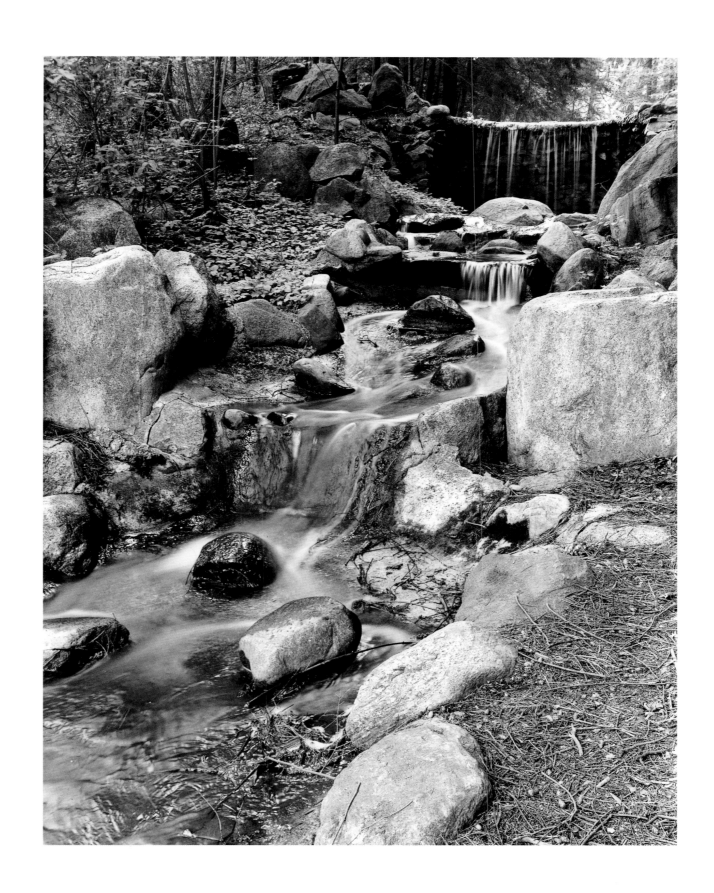

82 ❧ *Waterfall at Cranbrook Gardens*

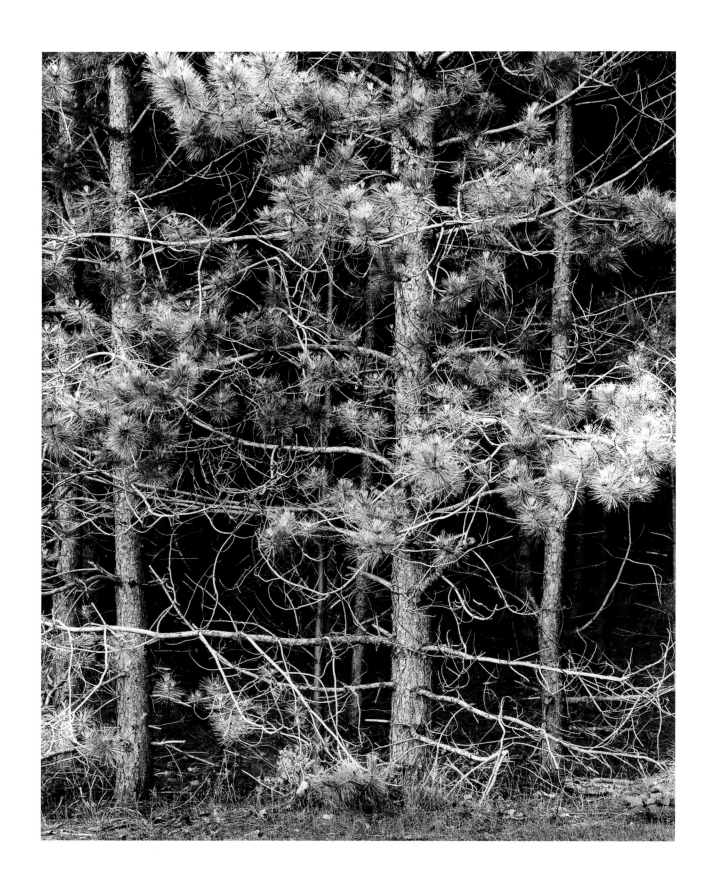

83 🌿 *Northern Pines*
GLEN ARBOR

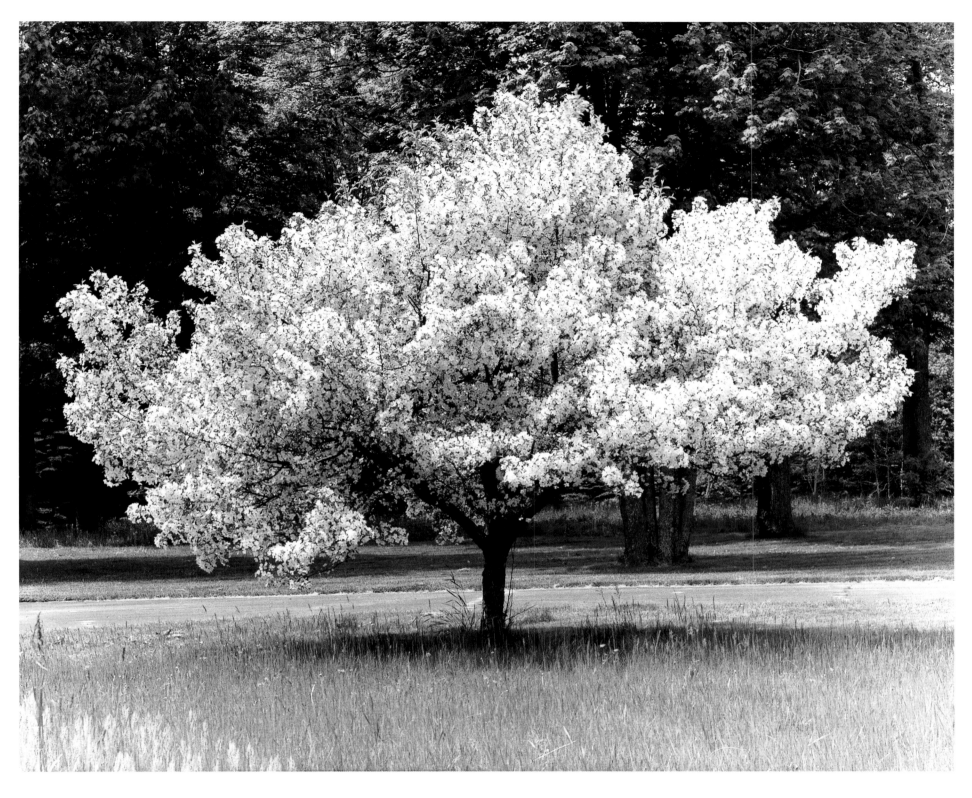

❧ *Cherry Blossoms*
CHEBOYGAN

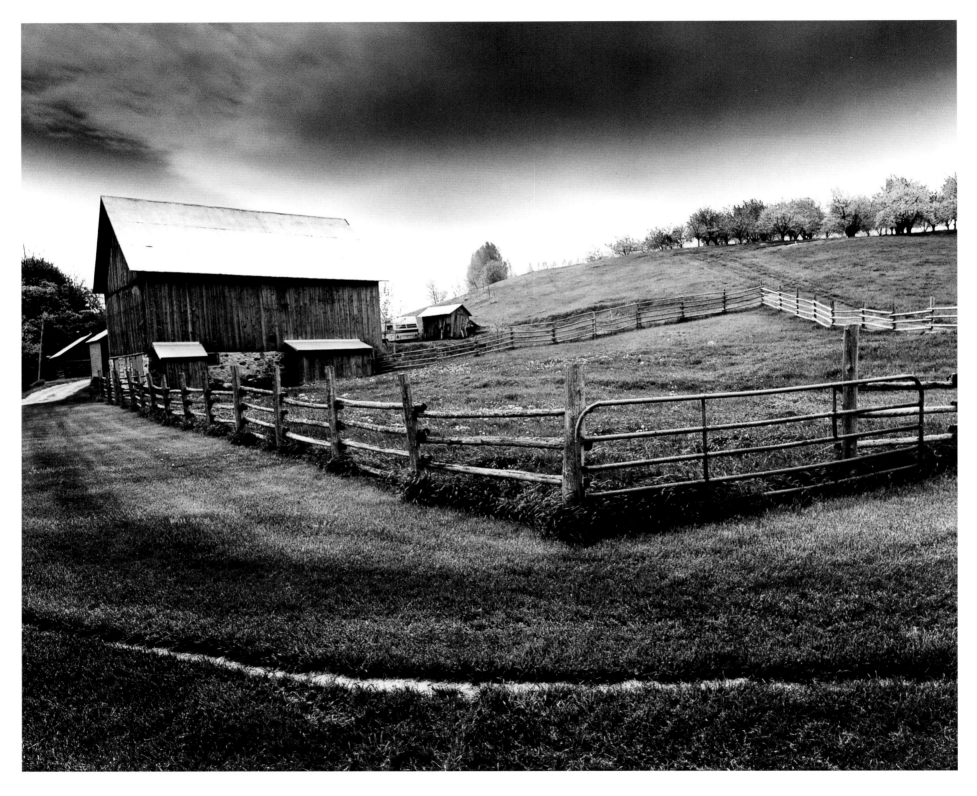

85 ❧ *On the Farm*
SUTTONS BAY

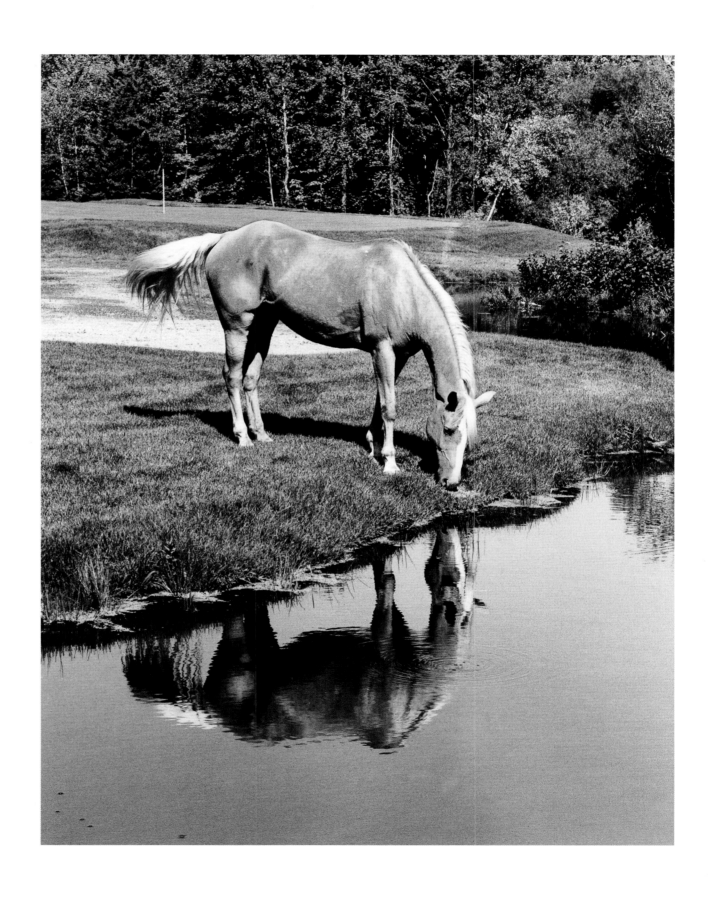

86 *Palomino Reflection*
ROTHBURY

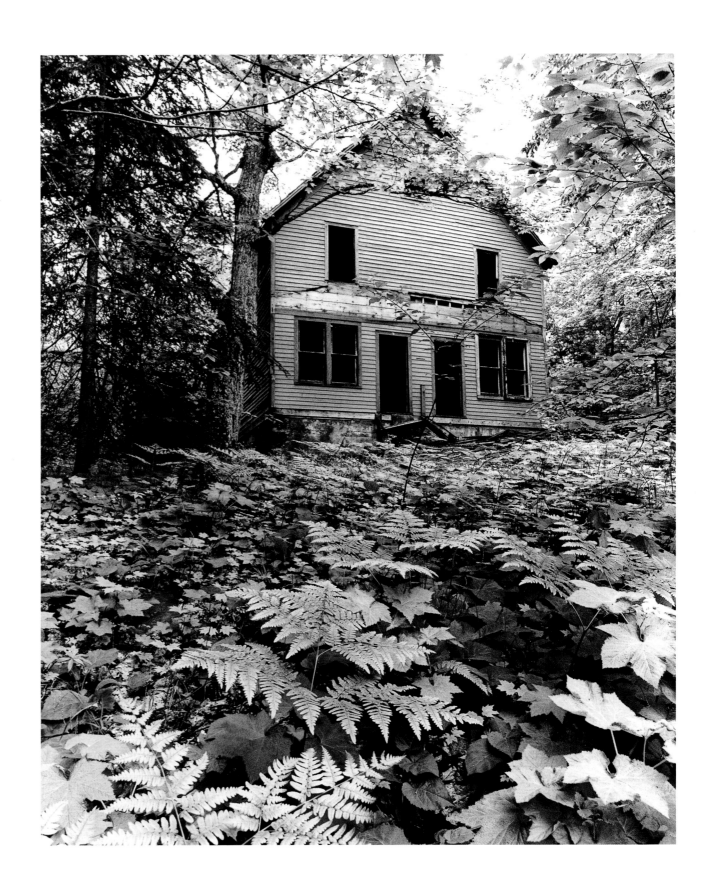

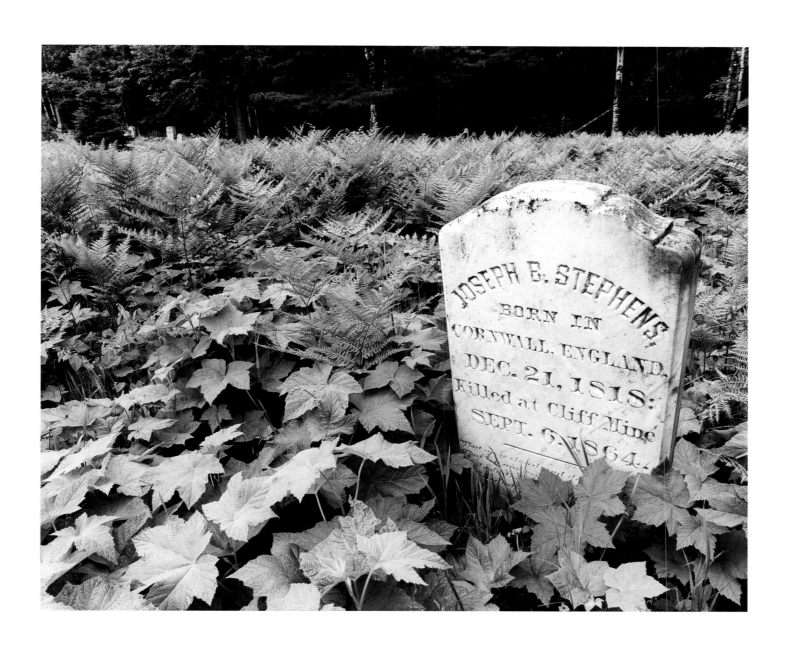

On the gravestone:

JOSEPH B. STEPHENS,
BORN IN
CORNWALL, ENGLAND,
DEC. 21, 1818;
Killed at Cliff Mine
SEPT. 6, 1864.

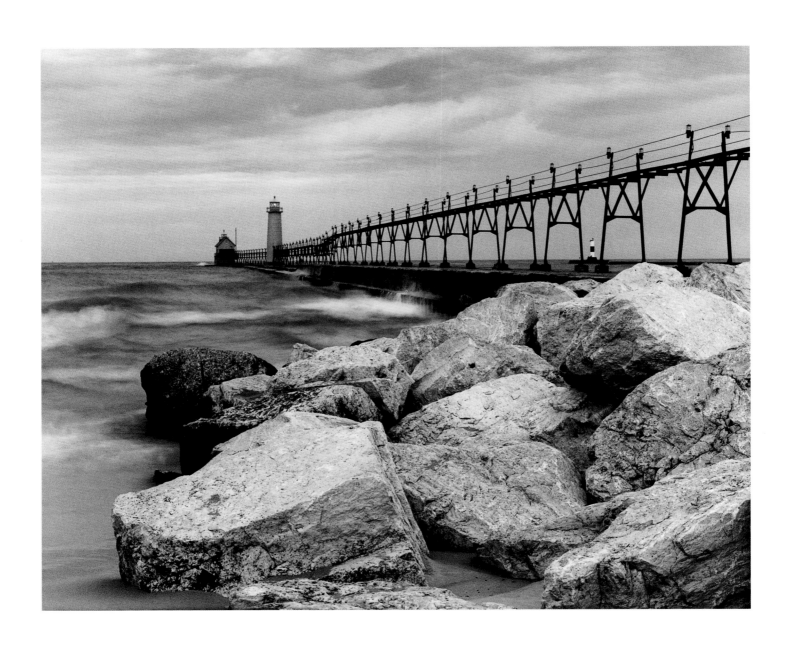

89 ❧ *Approaching Storm*
SOUTH PIER LIGHTHOUSE,
GRAND HAVEN

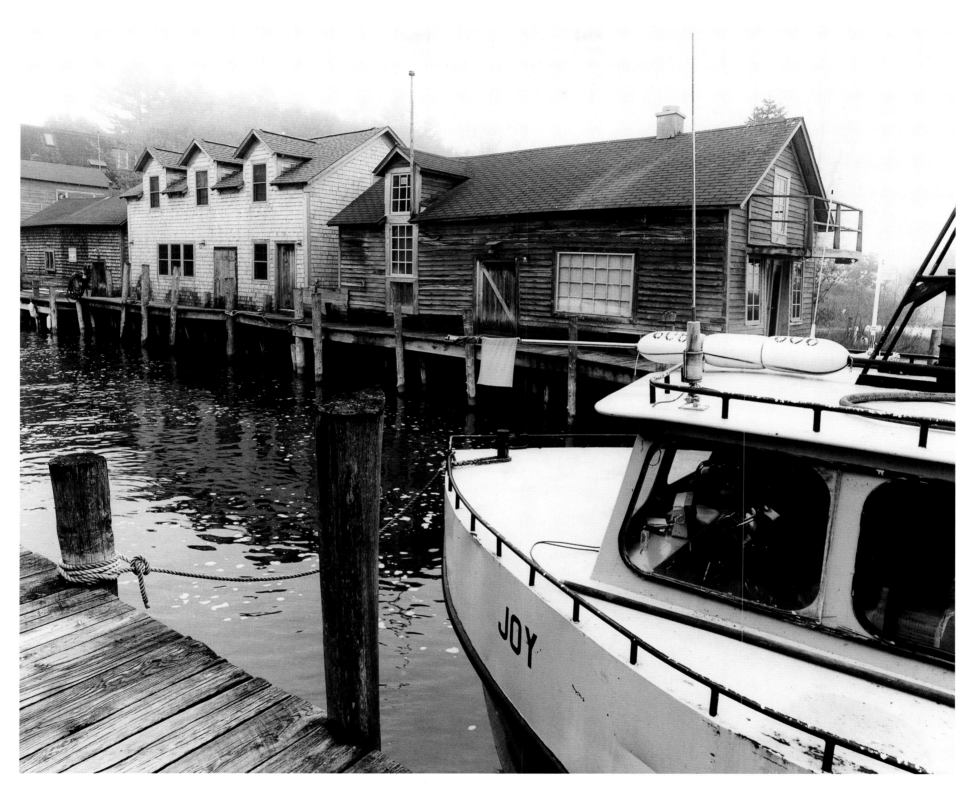

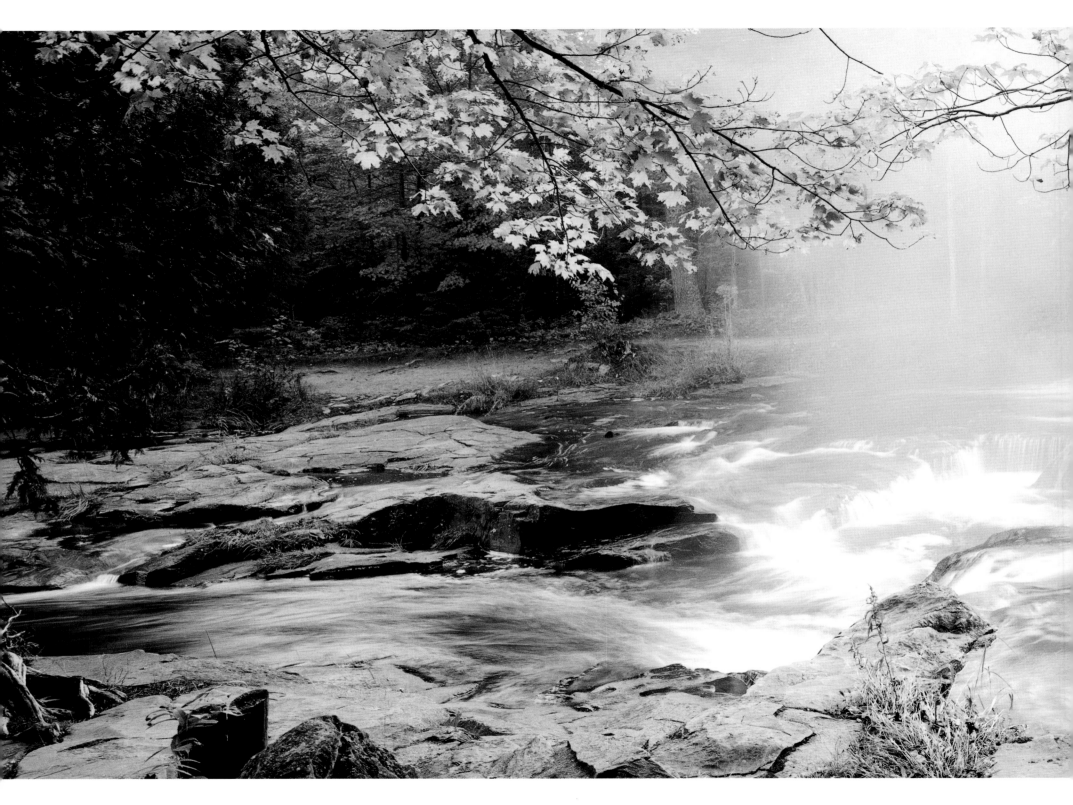

91 ❧ *Bond Falls Panorama*
BRUCE CROSSING

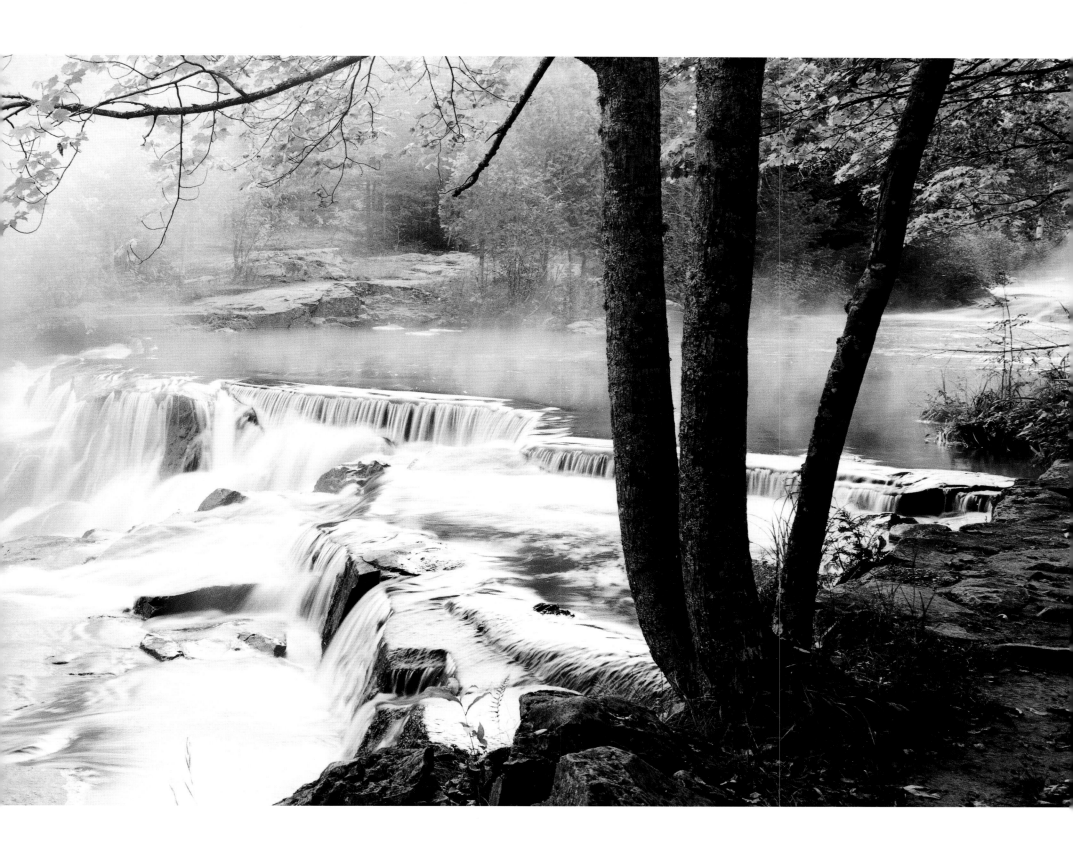

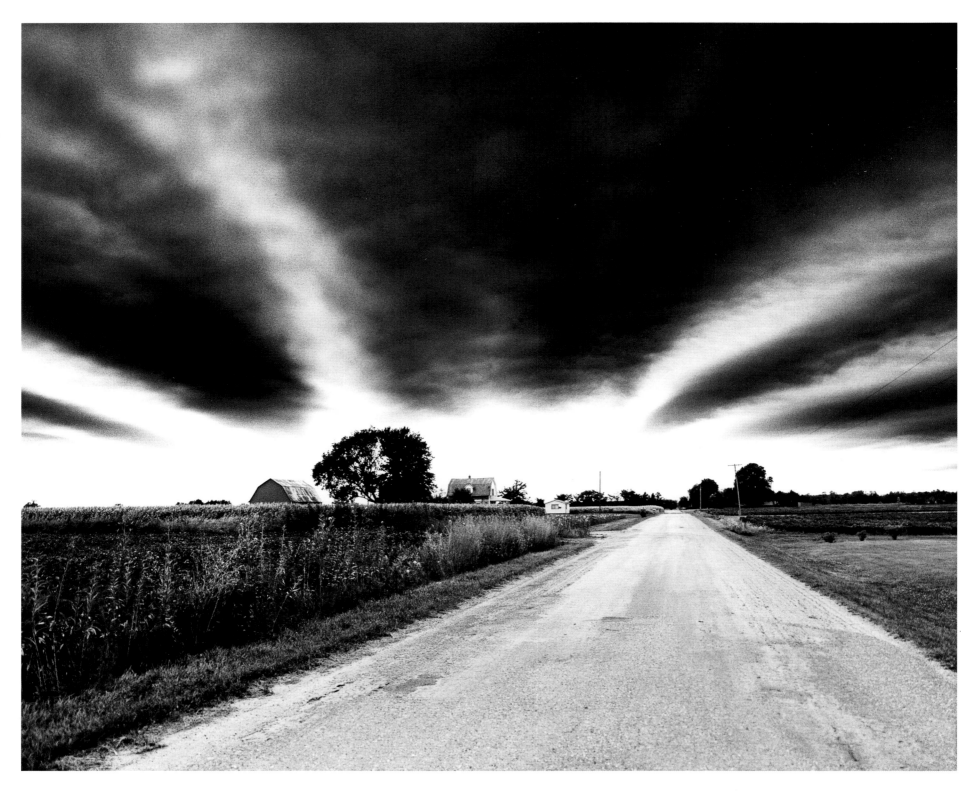

92 ❦ *Road & Clouds*
PINCONNING

Artist's Statement

Whether trekking along a quiet, narrow trail in the early morning to reach a distant location or waiting for a cloud formation to roll in, patience is a key component in capturing that special image. While working through the extremes of weather in search of the right light to capture a scene, a black-and-white photographer trains his or her eyes to previsualize and translate a colorful landscape into a distinct arrangement of shades of gray.

Yet for me, the efforts in the field only bring me partway to producing a photograph that meets my expectations. While many professional photographers are moving forward with the great technical achievements in photography, I have resisted the digitalization of my craft. Indeed, even as I work the camera to capture an image, I am thinking ahead to how I'll complete the photograph when I return home to my darkroom.

The following details are for those who are interested in the technical aspects of my equipment, lenses, and film choices. Four camera formats were used to produce the photographs in this book.

The Linhof is a 4×5 field camera that uses 4×5 sheet film. Listed here are the lenses used with their 35mm equivalent.

4×5 lens	35mm equivalent
90mm	28mm
105mm	35mm
135mm	40mm
210mm	65mm
300mm	90mm

The Pentax 6×7 and the Mamiya 7II are medium-format cameras producing negatives 6×7 centimeters or 2-1/4 × 2-3/4 inches in size.

Pentax 6×7 lens	35mm equivalent	Mamiya 7II	35mm equivalent
45mm	28mm	43mm	28mm

Pentax 6×7 lens	35mm equivalent	Mamiya 7II	35mm equivalent
75mm	35mm	50mm	35mm
90mm	50mm	80mm	45mm
165mm	85mm	150mm	80mm
300mm	200mm		

The Fujica 6×17 is a panorama camera producing negatives 6×17 centimeters, or 2-1/4 × 6-1/2 inches in size. It has a fixed 105mm lens that is equivalent to a normal 50mm lens on a 35mm camera. For even lighting across the width of the negative, all pictures are made with a spot-neutral density filter.

I also use a Canon 35mm camera with a full complement of lenses.

All original photographs for my exhibits are printed on Ilford Multigrade IV fiber-base paper and are selenium toned. For maximum sharpness and grain, my film choices are Fuji Acros 100 and Kodak T-Max 100. For action photographs, I use 400 ASA film.

Frontispiece. *Lower Bond Falls & Trees,* Bruce Crossing
Mamiya 7II, 50mm lens, f22, 1/4 sec.

Dedication. *Trees & Mist,* Traverse City
Linhof 4×5, 210mm lens, f32, 1/2 sec.

Plate 1. *Morning at Eagle Harbor,* Eagle Harbor
Pentax 6×7, 75mm lens, f22, 1/4 sec.

Plate 2. *Wetlands,* Walled Lake
Pentax 6×7, 75mm lens, f22, 1/4 sec.

Plate 3. *Bridge in the Woods,* Paulding
Pentax 6×7, 45mm lens, f22, 1/4 sec.

Plate 4. *Oriental Bridge,* Cranbrook Gardens, Bloomfield Hills
Linhof 4×5, 135mm lens, f22, 1/4 sec.

Plate 5. *Apple Blossom Lane,* West Bloomfield
Linhof 4×5, 210mm lens, f32, 1/4 sec.

Plate 6. *Vanishing Fence,* Bad Axe
Pentax 6×7, 45mm lens, f16, 1/30 sec.

Plate 7. *Sunflower Field,* Williamsburg
Linhof 4×5, 300mm lens, f64, 1/2 sec., red filter

Plate 8. *Early Morning Mist,* Southfield
Linhof 4×5, 135mm lens, f16, 1/8 sec.

Plate 9. *Farm in the Mist,* West Branch
Linhof 4×5, 90mm lens, f16, 1/4 sec.

Plate 10. *Winter on Fort Street, Trinity Episcopal Church,* Mackinac Island
Pentax 6×7, 45mm lens, f16, 1/15 sec.

Plate 11. *Winter Path,* Newberry
Pentax 6×7, 75mm lens, f16, 1/8 sec.

Plate 12. *Windmill at Greenfield Village,* Dearborn
Canon F-1, 17mm lens, f22, 1/4 sec., red filter

Plate 13. *Windmill & Tulips,* Holland
Linhof 4×5, 135mm lens, f22, 1/8 sec., red filter

Plate 14. *Upper Bond Falls,* Bruce Crossing
Fujica 6×17, 105mm lens, f32, 1/2 sec.

Plate 15. *Rope & Denim,* Montague
Pentax 6×7, 165mm lens, f5.6, 1/60 sec.

Plate 16. *Running Horses,* Rothbury
Pentax 6×7, 165mm lens, f8, 1/250 sec.

Plate 17. *Breaking Rein,* Rothbury
Pentax 6×7, 165mm lens, f8, 1/250 sec.

Plate 18. *Silhouettes at Sunset,* Rothbury
Pentax 6×7, 165mm lens, f8, 1/60 sec., red filter

Plate 19. *Day's End,* Rothbury
Pentax 6×7, 165mm lens, f11, 1/60 sec., red filter

Plate 20. *Crooked Lake,* Conway
Canon F-1, infrared film, 28mm lens, f8, 1/125 sec., red filter

Plate 21. *The Artist,* Paulding
Canon F-1, infrared film, 28mm lens, f11, 1/125 sec., red filter

Plate 22. *Bench on the Dock,* Conway
Canon F-1, infrared film, 28mm lens, f11, 1/125 sec., red filter

Plate 23. *Lily Pads at Crooked Lake,* Conway
Canon F-1, infrared film, 28mm lens, f11, 1/125 sec.,
 red filter

Plate 24. *The Farm at Maybury State Park,* Northville
Linhof 4×5, infrared film, 135mm lens, f11, 1/125 sec.,
 red filter

Plate 25. *Sunflower Sentinels,* Elk Rapids
Pentax 6×7, 45mm lens, f16, 1/125 sec.

Plate 26. *Taking Flight,* Detroit
Pentax 6×7, 45mm lens, f5.6, 1/250 sec., red filter

Plate 27. *Birch Trees & Mist,* Negaunee
Linhof 4×5, 135mm lens, f22, 1/15 sec.

Plate 28. *Dunes & Fence,* Sleeping Bear Dunes National
 Lakeshore
Mamiya 7II, 43mm lens, f16, 1/15 sec., red filter

Plate 29. *Point Betsie Lighthouse,* Frankfort
Pentax 6×7, 45mm lens, f16, 1/15 sec., red filter

Plate 30. *Six Boats,* Rothbury
Fujica 6×17, 105mm lens, f32, 1/8 sec.

Plate 31. *Covered Bridge,* Walled Lake
Pentax 6×7, 45mm lens, f22, 1/8 sec.

Plate 32. *Beneath the Zilwaukee Bridge,* Zilwaukee
Pentax 6×7, 90mm lens, f11, 1/30 sec.

Plate 33. *Spirit of Detroit,* Detroit
Canon F-1, 17mm lens, f11, 1/30 sec., orange filter

Plate 34. *"Transcending," Hart Plaza,* Detroit
Mamiya 7II, 43mm lens, f11, 1/30 sec., red filter

Plate 35. *Final Assembly, the Rouge,* Dearborn
Pentax 6×7, 90mm lens, f22, 1/4 sec.

Plate 36. *Pipes, the Rouge,* Dearborn
Pentax 6×7, 45mm lens, f8, 1/125 sec.

Plate 37. *The Violist,* Interlochen
Pentax 6×7, 165mm lens, f22, 1/30 sec.

Plate 38. *Columns in the Law Quad,* Ann Arbor
Pentax 6×7, 165mm lens, f22, 1/8 sec.

Plate 39. *Forest Floor at Iargo Springs,* Huron-Manistee
 National Forest, Oscoda
Pentax 6×7, 90mm lens, f22, 1/15 sec.

Plate 40. *Old House & Flag,* Omer
Pentax 6×7, 90mm lens, f16, 1/30 sec.

Plate 41. *Two Boys Fishing,* Northport
Pentax 6×7, 165mm lens, f11, 1/60 sec., red filter

Plate 42. *Riding Bikes,* Troy
Canon F-1, 200mm lens, f8, 1/60 sec., red filter

Plate 43. *Reeds & Ripples,* Conway
Pentax 6×7, 90mm lens, f22, 1/8 sec.

Plate 44. *Sunrise at Crooked Lake,* Conway
Pentax 6×7, 90mm lens, f22, 1/4 sec., red filter

Plate 45. *Lower Bond Falls,* Bruce Crossing
Fujica 6×17, 105mm lens, f22, 1/8 sec.

Plate 46. *Red Pines,* Empire
Pentax 6×7, 300mm lens, f45, 1/4 sec.

Plate 47. *Scott Falls,* Munising
Pentax 6×7, 90mm lens, f22, 1/2 sec.

Plate 48. *Falls, Trees & Rocks,* Bruce Crossing
Pentax 6×7, 90mm lens, f22, 1/2 sec.

Plate 49. *Cascades of Bond Falls,* Bruce Crossing
Linhof 4×5, 90mm lens, f32, 1/2 sec.

Plate 50. *Madino Falls,* Presque Isle
Pentax 6×7, 165mm lens, f22, 1/8 sec.

Plate 51. *Detail of Bond Falls,* Bruce Crossing
Linhof 4×5, 300mm lens, f45, 1/2 sec.

Plate 52. *Waterfall Abstract,* Bruce Crossing
Pentax 6×7, 165mm lens, f22, 1/2 sec.

Plate 53. *Orpheus,* Cranbrook Gardens, Bloomfield Hills
Linhof 4×5, 300mm lens, f22, 1/15 sec.

Plate 54. *Leonardo da Vinci's Horse: The American Horse,*
 Frederik Meijer Gardens & Sculpture Park, Grand
 Rapids
Mamiya 7II, 50mm lens, f16, 1/30 sec., red filter

Plate 55. *State Capitol Interior,* Lansing
Pentax 6×7, 45mm lens, f22, 1 sec.

Plate 56. *Dome of the State Capitol,* Lansing
Pentax 6×7, 75mm lens, f11, 1/2 sec.

Plate 57. *Tawas Point Lighthouse,* Tawas Point State Park
Mamiya 7II, 43mm lens, f16, 1/30 sec., red filter

Monte Nagler began to develop his own artistic vision after studying in an intensive workshop with Ansel Adams. A member of the esteemed and exclusive Cameracraftsmen of America, Monte was recognized by *Outdoor Photographer* magazine as one of five Modern Landscape Masters in 2001.

Monte has been the National Fine Arts Photography Spokesperson for Chevrolet Tahoe and is a recipient of the prestigious Artist in Residence Award from the Farmington Area Arts Commission. In addition to the many awards and acknowledgments he has received, the State of Michigan Senate and House have honored him with proclamations for his contributions to fine art photography.

Monte's photographs can be found in many private and public collections, including the Detroit Institute of Arts, Center for Creative Photography in Tucson, Brooklyn Museum, Grand Rapids Art Museum, Dayton Art Institute, University of Michigan Museum of Art, Ford Motor Company, General Motors Corporation, DaimlerChrysler Corporation, BASF Corporation, and Visteon Corporation. Galleries and agents throughout the United States also represent Monte's photographs.

He is also a noted writer, lecturer, and teacher of photography. His previous books are *How to Improve Your Photographic Vision* and *Statements of Light*. Monte Nagler lives in Farmington Hills.

You are invited to further explore Monte's work at his web site, www.montenagler.com.

Monte Nagler's Michigan

Text design and typesetting by Jillian Downey

Printed and bound in China at Everbest

Text face is Bembo, from the library of Adobe Systems Inc., and was produced by Monotype in 1929, based on a face cut by Francesco Griffo in Venice in 1495

Duotones printed in Black and PMS Warm Gray 9, using 200 line-screen

Printed on 170gsm Hannoart paper